CHEETHAM HILL, CRUMPSALL, BLACKLEY & MOSTON

THROUGH TIME

Jean & John Bradburn

AMBERLEY PUBLISHING

First published 2013

Amberley Publishing
The Hill, Stroud, Gloucestershire, GL5 4EP
www.amberley-books.com

Copyright © Jean & John Bradburn, 2013

The right of Jean & John Bradburn to be identified as the
Authors of this work has been asserted in accordance with
the Copyrights, Designs and Patents Act 1988.

ISBN 978 1 4456 1772 5 (print)
ISBN 978 1 4456 1790 9 (ebook)

British Library Cataloguing in Publication Data.
A catalogue record for this book is available from the
British Library.

Typesetting by Amberley Publishing.
Printed in Great Britain.

Cheetham Hill

In the early decades of the nineteenth century, Cheetham Hill was still a quiet, rural village with a toll road to Manchester and very little passing traffic. By 1905, it was a bustling village. Cheetham Hill's story was influenced by its position just north of Victoria Station. The 1880s saw the arrival of Jewish families fleeing discrimination from Eastern Europe, especially Russia, Poland and Lithuania. They found refuge here after arriving at Victoria Station by train from Hull. Many had planned to travel via Liverpool to America but perhaps, having travelled so far, they decided to stay in Manchester. In the early days, many lived in tenement blocks near to the city in what was then called York Street. Most spoke no English so took work with other Jews in the numerous clothing factories, and so a community was formed. Small local synagogues called *chevras* were formed and as the Jewish community prospered, they built permanent, beautiful synagogues. By the early twentieth century, Cheetham had a large Jewish population and nine synagogues. Michael Marks was a Jewish immigrant who lived in Cheetham Hill with his family, and he and Thomas Spencer opened the first Marks & Spencer store on Cheetham Hill Road in 1893. The business grew considerably over the following years and in 1901, the company's first headquarters was built on Derby Street. As families prospered, they moved further up the hill to build better homes and Cheetham Hill became popular with wealthier Mancunians.

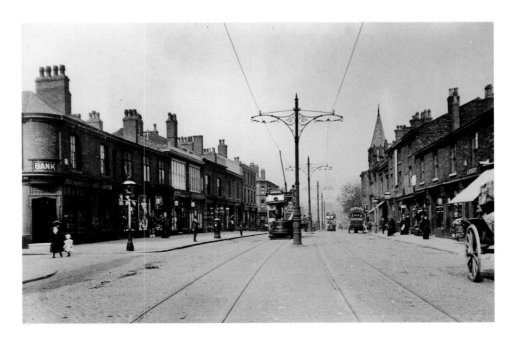

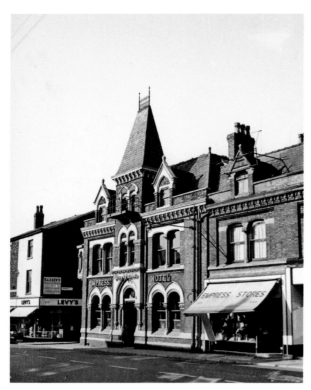

The Empress Hotel, 1959
The Empress Hotel was built in a grand style around 1900. It was a thriving Threlfall's Brewery house in 1959 when this photograph was taken. Levy's upholsterers and home furnishings are on the corner. This grand hotel is now a computer warehouse and its fine roof turret is gone.

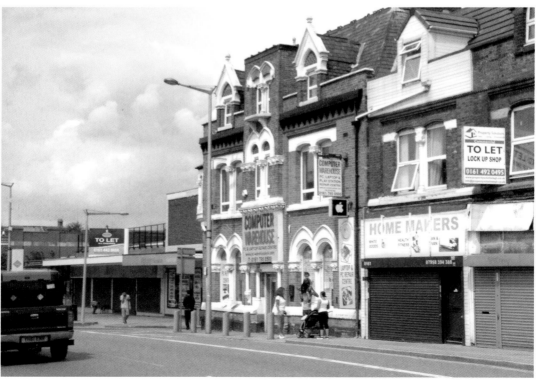

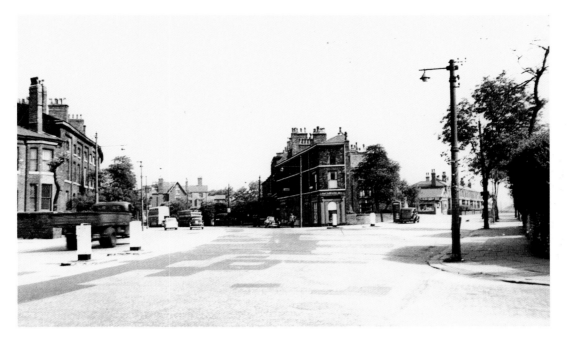

Alms Hill Road, 1959

Alms Hill was popular as a beauty spot, a lovers' lane and children's play area. It was a popular shortcut from Saint Luke's to Crumpsall. The site was once the scene of tragedy when in 1924, William Duff (aged nine) of Honey Street was killed while playing in a sandpit. There were plans to expand the Northern Hospital to Alms Hill when Sir Edward Holt donated land. Here we see the junction of Alms Hill Road today.

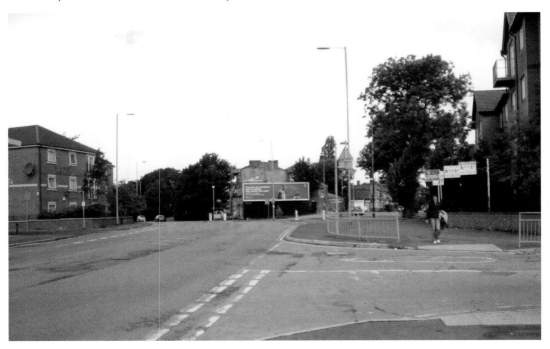

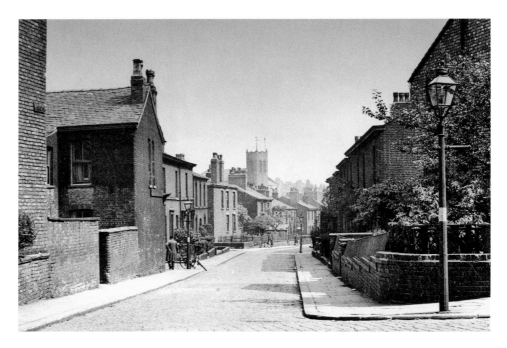

Coke Street, 1946

This view is from Leicester Road looking towards George Street, showing St Mark's church in St Mark's Lane. The church was consecrated in 1794. Built of red brick, it was large enough to accommodate about 1,000 people. The Revd Charles Ethelston became the first vicar. As we see from the modern photograph, the church closed in 1982 and was demolished around 1998.

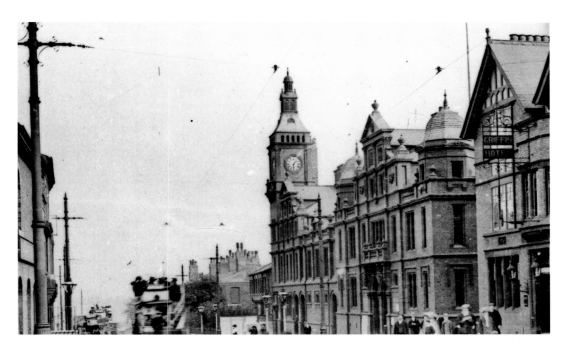

Griffin Inn, 1900

Looking down Cheetham Hill Road is The Griffin Hotel. The Manchester & Salford Directory of 1895 shows Frank Midwinter as the landlord. A busy bowling green flourished behind The Griffin. Beyond are Cheetham Baths & Washhouses, opened in 1894, with their grand clock tower, now sadly demolished. The tram is probably the No. 10 or 11, which ran from Cheetham Hill to Alexandra Park. The Griffin is now closed and we see Bhatti Fabrics in the modern photograph.

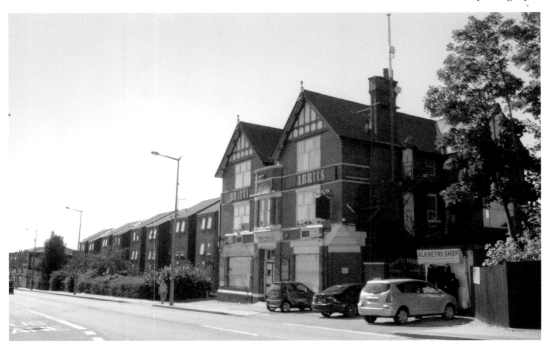

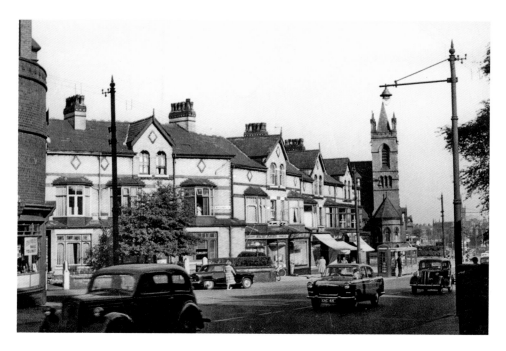

Cheetham Hill Road, 1959

A summer's day at the corner Woodlands Street busy, even then, with motorists. We see Trinity United church. It was built in red brick and red terracotta as a Presbyterian church in 1900, by the architect Henry Price. In the 1970s, the church became part of the United Reform church. In the 1980s it absorbed the congregation of St Luke's and formed a Local Ecumenical Partnership. Now it embraces the ethnic diversity of Cheetham Hill, sharing the building with the Urdu speaking New Life church.

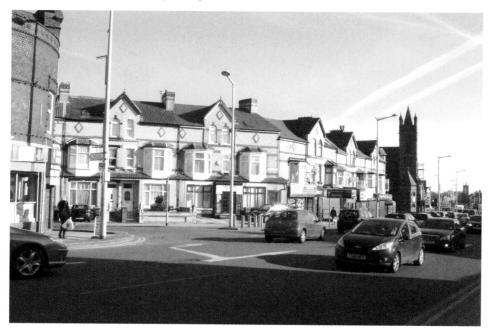

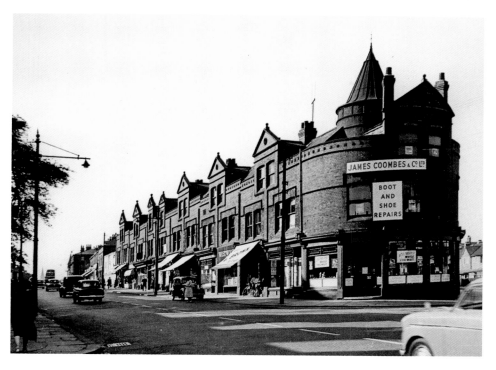

Cheetham Hill Road, 1959

The same corner looking north and featuring James Coombes boot and shoe repairs. This is an imposing terrace of shops featuring fine roof turrets sadly lost in the modern photograph.

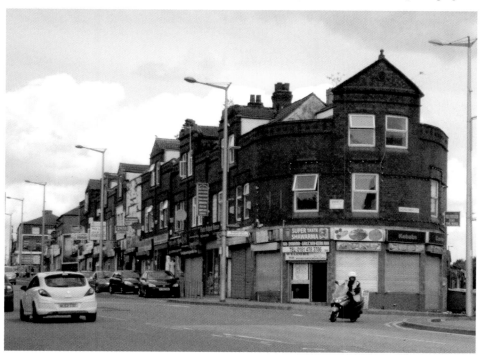

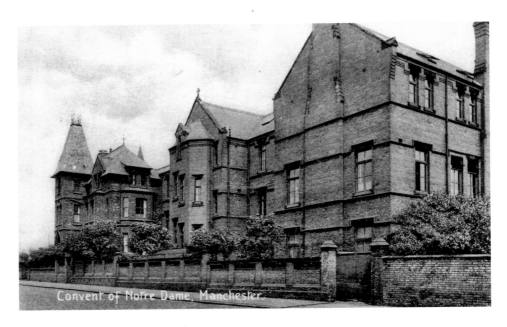

Convent of Notre Dame, Manchester

Notre Dame Convent School

The school was staffed by the Sisters of Notre Dame of Namur, a teaching order of nuns that had originated in southern Belgium but who, like a lot of religious teaching orders in the nineteenth century, had sent a delegation of nuns over to Manchester and other northern towns to cater for the education of the children after the massive influx of Irish people. It was demolished in the 1980s. Near Bignor Street was a terrace of houses set back a little from Cheetham Hill Road. One of these had a plaque saying that Beecher Stowe, author of *Uncle Tom's Cabin,* stayed there in 1851. We now see the modern homes on the site. Good to see that a little of the historic building has been retained!

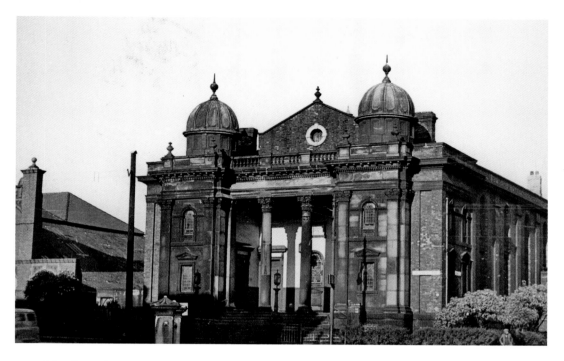

The Great Synagogue, 1959

The Great Synagogue (Old Congregation), designed by Thomas Bird, opened on 14 March 1858 and closed in 1974. It was demolished in 1986. It was built in the Italian manner, with large Corinthian order columns and pilasters. It stood opposite the town hall and next to the fine library, dated 1876, which still stands today. Today, Influence fashion house stands on the site.

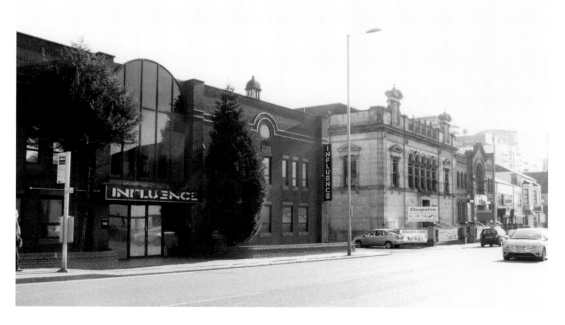

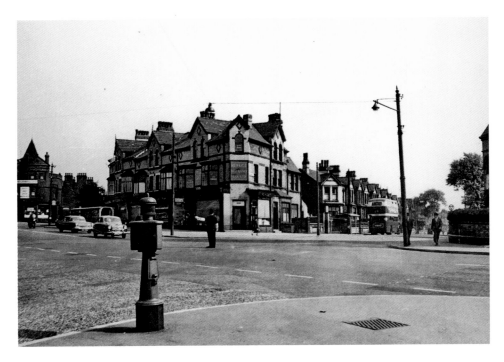

Greenhill Road, 1959

The policeman is in control here. Today, the busy junction needs traffic lights. The 1893 Ordnance Survey map shows Green Hill Lodge standing on the corner leading up to Green Hill. The house was built by Samuel Jones, a banker. He died at Greenhill in 1819, and the house was occupied by Edward Lloyd for some years afterwards.

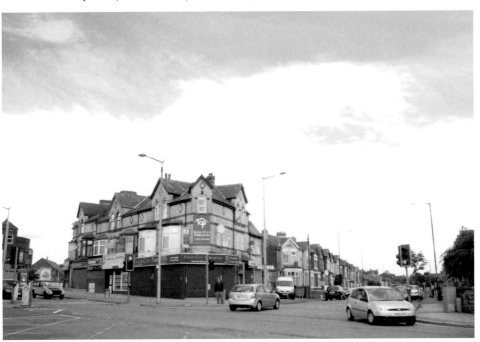

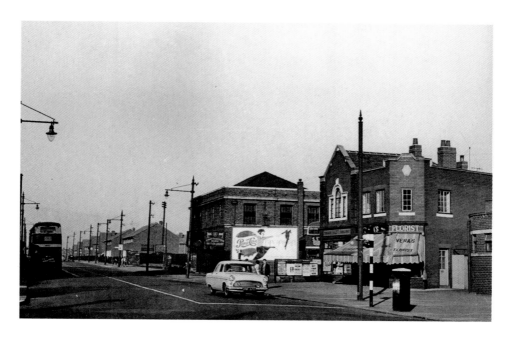

Queens Road, 1959

Queens Road, looking towards Rochdale Road. Opposite is the bus depot, now a Transport Museum. This is well worth a visit! The earliest electric tram route started in Cheetham Hill. The first, and believed to be the biggest, tram depot in Europe was built here in Queens Road. The service from Cheetham Hill Road to Rochdale Road commenced in July 1901. In 1902, it was extended to Bell Vue and then extended to Brooks Bar, becoming the No. 53 circular route. I remember Finnigan's dancehall on the opposite corner. The modern image shows the St Patrick's Day parade heading for the city centre from the new Irish World Heritage Centre.

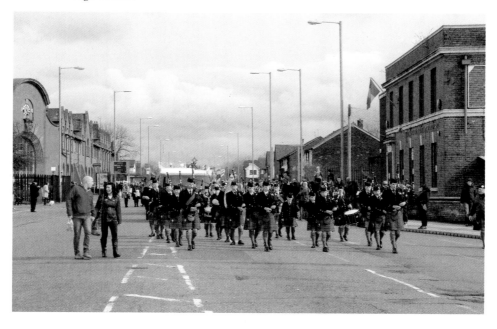

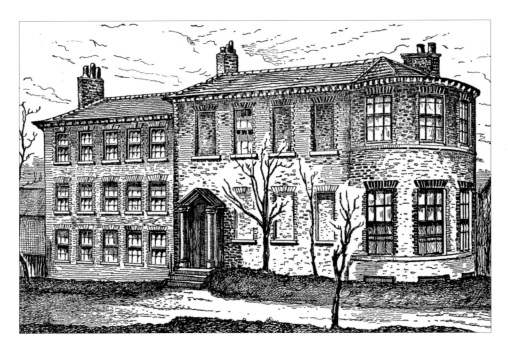

Stocks House, 1890

What a fine house! But sadly, it is long gone. The outbuildings were numerous, and the grounds were laid out in an ornamental manner with gardens, shrubberies, ponds and walks. Charles Dickens visited the house in 1837 when it was owned by Gilbert Winter. It is believed that he met William and Daniel Grant here and modelled the Cheeryble brothers in *Nicholas Nickleby* on them. We now see the busy Fort Shopping Centre.

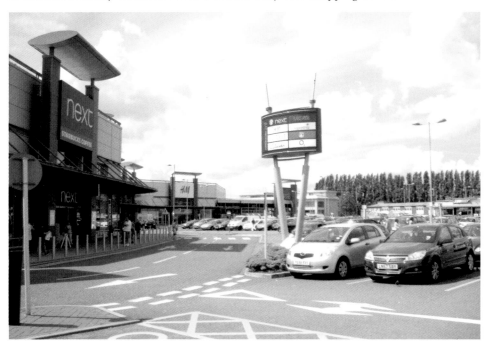

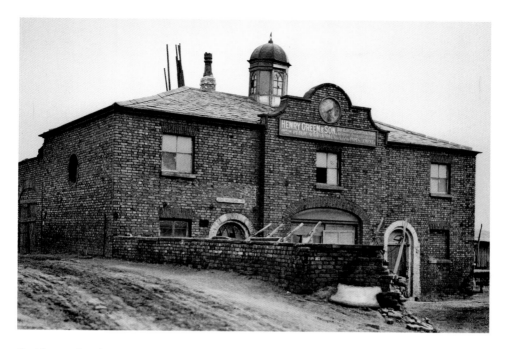

Stables to Stocks House, 1909

The grand stables are gone and now we see the premises of Henry Green & Son, bricklayer's and contractor's. The farm and stables sat just behind Stocks House. Duffield's map of 1845 shows the position opposite Dirty Lane, now Elizabeth Street. How grand to have a cupola on a farm!

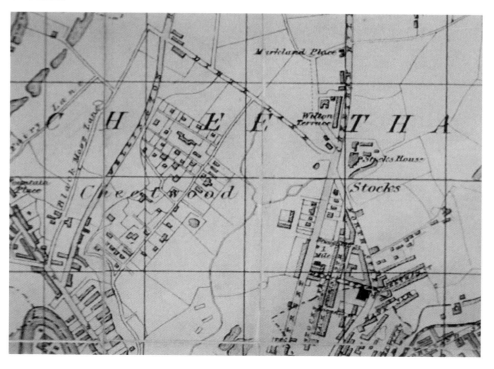

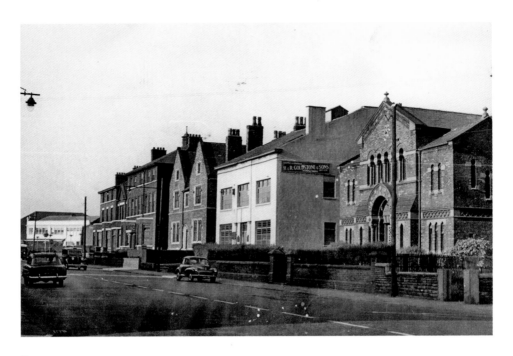

Synagogue, 1959

The Spanish and Portuguese synagogue, built in 1874. A fine example of Victorian architecture, built in the Moorish style. It is now lovingly preserved as the Manchester Jewish Museum, telling the story of Manchester Jewry, and is really worth a visit. It is the oldest surviving synagogue in Manchester.

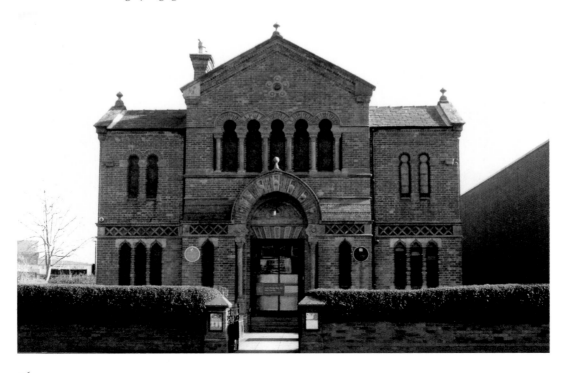

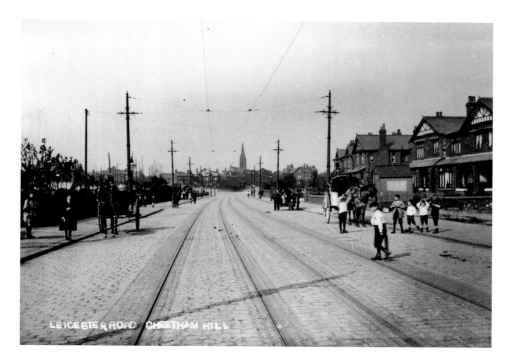

Leicester Road, 1900

Looking north towards the Wesleyan Methodist chapel. The scene is busy, with horse-drawn carriages soon to be replaced by the electric trams. This was Salford Corporation Tramway, and originally services from Weaste in Salford to Whitefield used the route. The scene is now dominated by trees and the tram lines are long since gone.

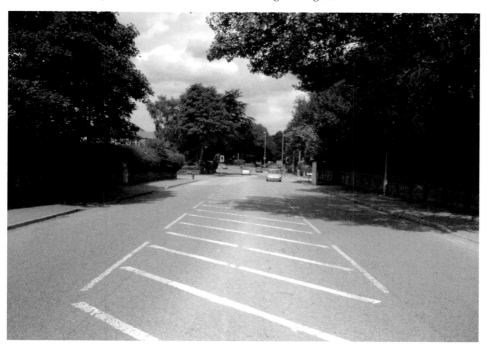

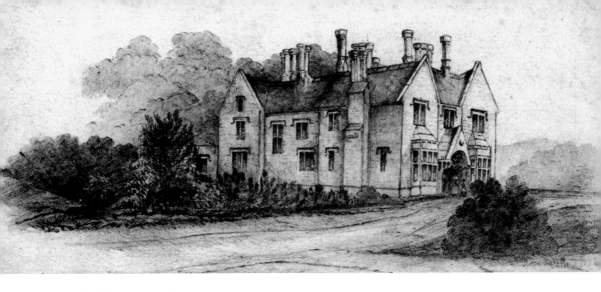

The Parsonage, 1875

This fine building is long demolished. We can see from the 1845 Duffield map that it was between Alms Hill and Green Hill. Later maps show it as St Luke's rectory surrounded by gardens.

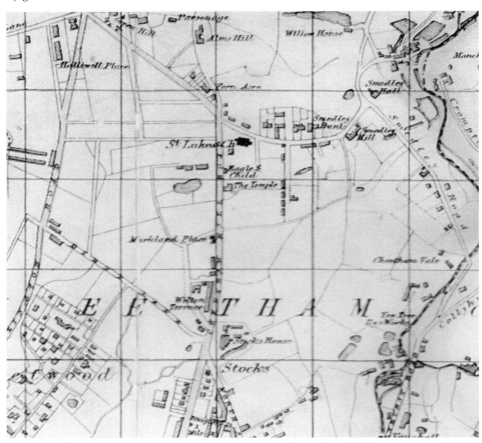

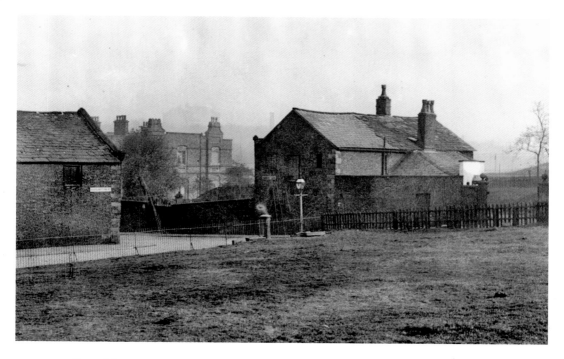

Smedley Old Hall, 1924

This was the home of Edward Chetham, who died in 1769. It's hard to imagine, but this was a rural area near the tranquil River Irk. The terraced gardens, bowling green and the Italian garden were much admired. In 1881, it was advertised in the *Guardian* as an old-fashioned, roomy house with stabling and large gardens.

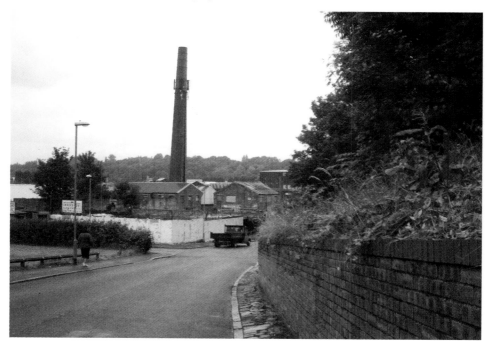

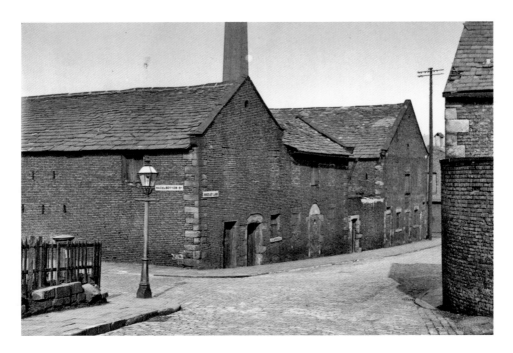

Smedley Lane, 1939

Old buildings near Smedley Old Hall, on the corner of Smedley Lane and Hazelbottom Road. The chimney still dominates the scene, but for how long? In 1886, the owners of the dye works were taken to court under the new Sanitary Act for smoke nuisance in the area. Surprisingly, Mr Malcom Ross, who lived in the hall, came to their defence. He stated in court that 'he had never found the black smoke a nuisance'. Perhaps the magistrate found this hard to believe, as an abatement order was issued!

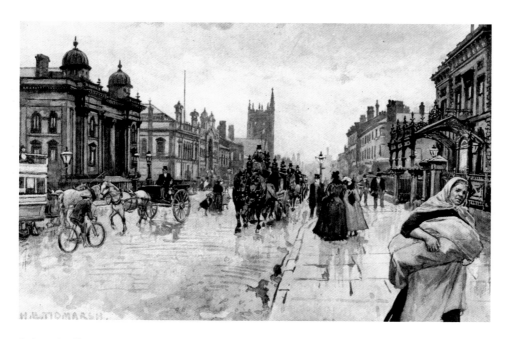

Saint Chad's, 1895

A fine view, looking down towards the city centre. St Chad's church was, and still is, an imposing sight. It was the first Catholic chapel in Manchester, and it was originally built in 1776 in Rook Street in the city centre. In 1845, funds were raised to build a new church on Cheetham Hill Road. We also see the synagogue and the free library built in 1876. On the right, we can see the town hall, which still stands today. Built in 1853, it has a fine iron porch. How Manchester has been transformed, with Beetham Tower now dominating the skyline. This is site of the Hilton Hotel and apartments. It is the tallest residential building in the country.

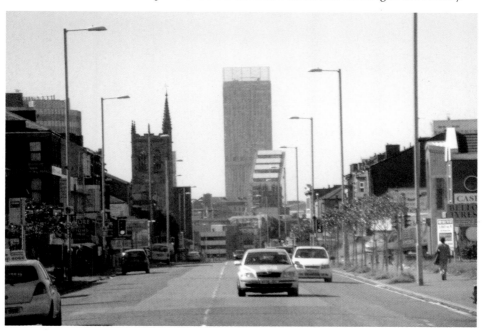

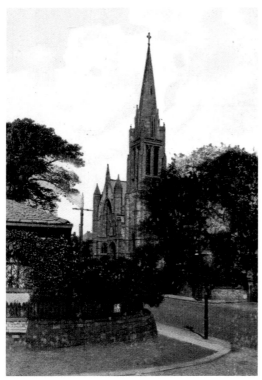

Wesleyan United Free Chapel, 1910
The fine Wesleyan Methodist chapel was erected in 1872 and seated 900 people. The church replaced a preaching room and Sunday school on Fountain Street, now Arlington Street. The church was demolished around 1967. It is always sad to see a church demolished, but even sadder to see a cemetery moved. This was for the development of a Tesco supermarket. A memorial has been retained, as we can see in the modern photograph.

Crumpsall

The name Crumpsall derives from old English and means a 'crooked piece of land beside a river'. Crumpsall lies on rising ground above the River Irk. It is dominated by the North Manchester Hospital. Sitting just below the Heaton estates, the Wilton name is found everywhere in Crumpsall, as the family were major landowners. In 1830, the population was 910. 'In this pleasant village are several handsome residences, belonging to the opulent merchants and manufacturers of Manchester.' An example of how well-to-do Crumpsall was in 1848, is that Polish composer Frederic Chopin was the guest of the Schwabe's family at Crumpsall House on Crumpsall Lane.

Within the space of just fourteen years (1897–1911), the population of Cheetham and Crumpsall more than doubled, from 26,000 to 60,000. House building boomed, farmland disappeared, along with the wild flowers that grew in profusion, the salmon in the River Irk, and the brook in which watercress grew.

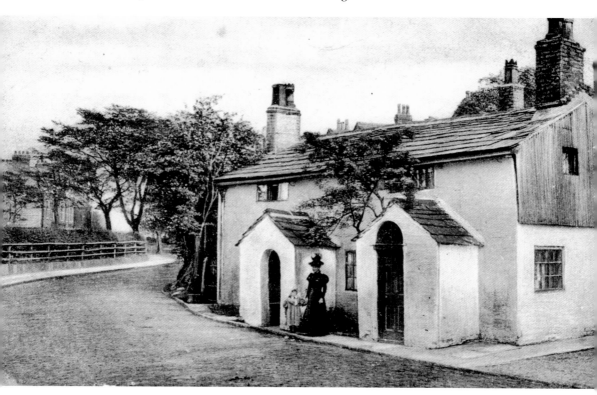

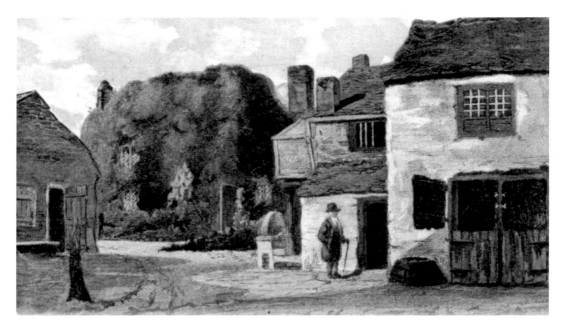

White Smithy Bar Toll, 1780
The toll bar stood at the corner of Middleton Road. It was known as the White Smithy bar because of the whitewashed smithy that stood on the opposite corner of the road. An occasional farmer's cart and a few horse-drawn coaches were the only vehicles that passed through the sleepy little village.

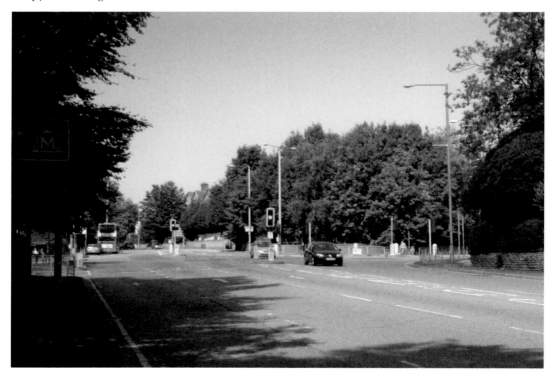

Crumpsall Biscuit Works, 1960

The Co-operative Wholesale Society opened the Crumpsall Biscuit Works in Hazelbottom Road, Lower Crumpsall, around 1873. Here we see the river valley and the weir. It was a huge local employer and remembered fondly by local children, as on certain days you could purchase a large bag of broken biscuits for one shilling. The valley is now dominated by an industrial estate.

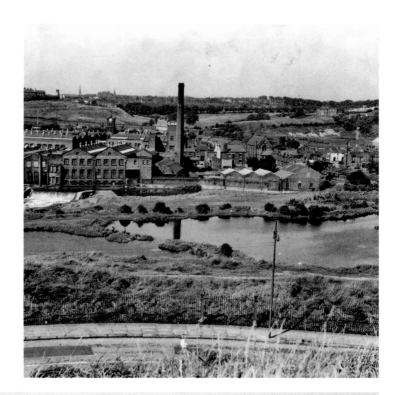

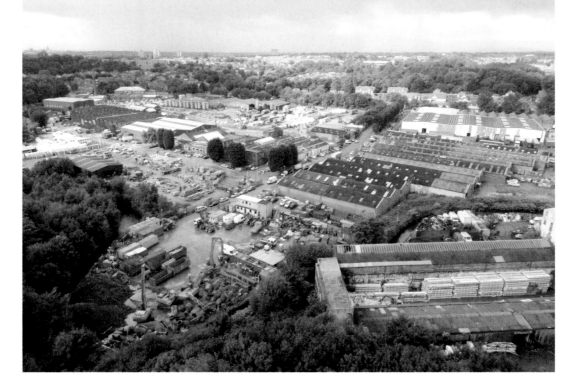

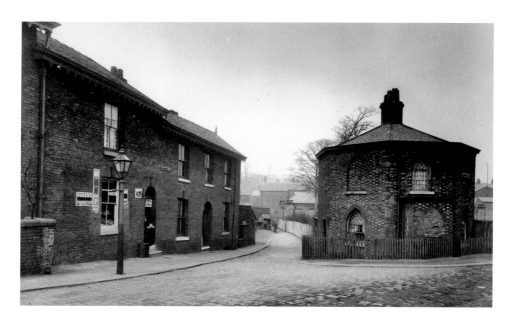

Delaunays Road, 1903

This road was named after the Delaunay family. In 1788, Angel Delaunay from Rouen introduced Turkey red dyeing into Crumpsall and Blackley, and built up a great business. They built a bridge over the Irk for their coach road from Blackley to Cheetham Hill. These old buildings are now long gone, and the corner is dominated by the Hexagon Tower. One cannot speak of Blackley without mentioning Imperial Chemical Industries (ICI), remembered fondly as a wonderful family-friendly company. The tower was designed by Richard Seifert, and it takes its name from the foundation of synthetic dyes, hexagonal benzene.

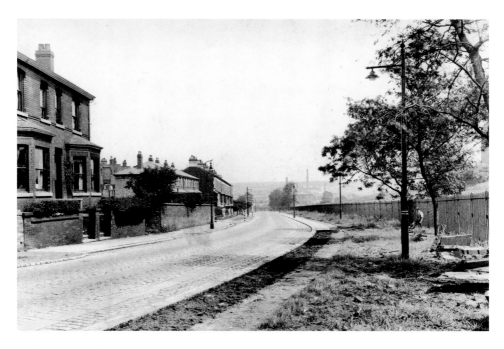

Delaunays Road, 1939

Delaunays Road, leading down to the industry of Blackley village. Ivan Levinstein arrived in Blackley from Berlin in 1864. He took over Delaunay's old works and continued the manufacture of dyestuffs. Unsurprisingly, the *Manchester Guardian* reports numerous cases of air pollution being brought before the courts. The hospital grounds are on the right. How pleasant the road looks without all the cars!

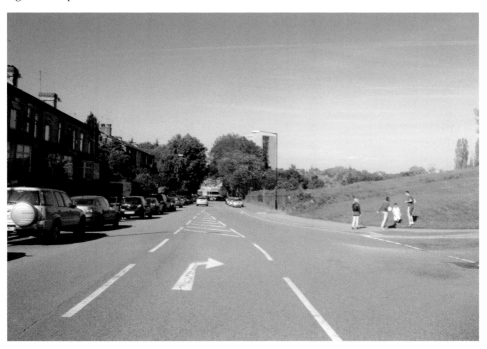

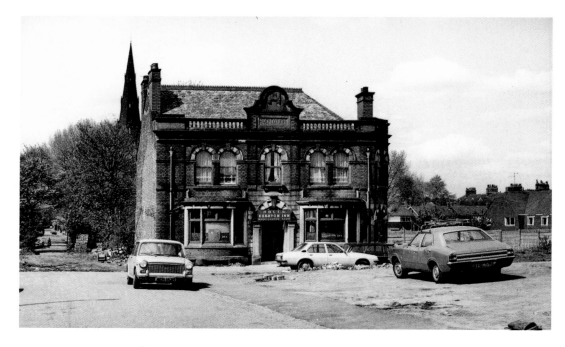

Egerton Inn, Hanlon Street, 1970

Rebuilt in 1914, this fine building still stands today. Behind we see the Wesleyan church, which sadly is now demolished. Like so many inns, it is named after the Egerton family, who owned much of Lancashire and Cheshire. Sir Thomas Egerton became the 1st Earl of Wilton. In 1909, Wilson's brewery was at the high court in a dispute over the licenses of the Egerton Inn and the Church Inn, which stood nearby.

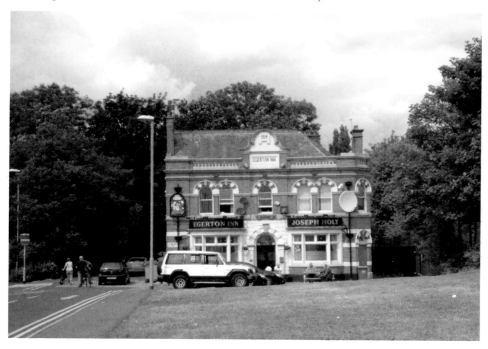

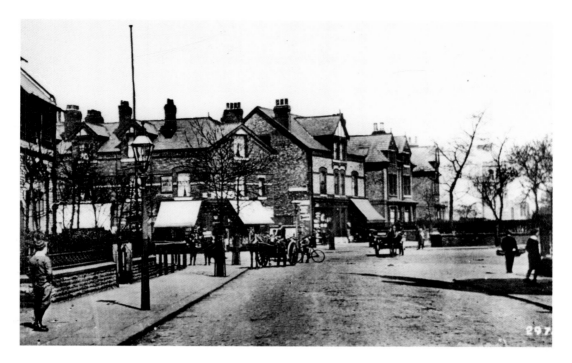

Crumpsall Green, 1895
This shot is from Lansdowne Road looking towards Delaunays Road. We can just see
St Matthew's church in the right hand corner. Crumpsall Lane is on the left, leading down
to Crumpsall Station. We now have Crumpsall Constitutional Club on the corner.

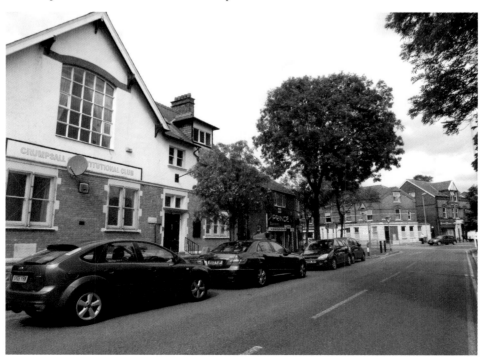

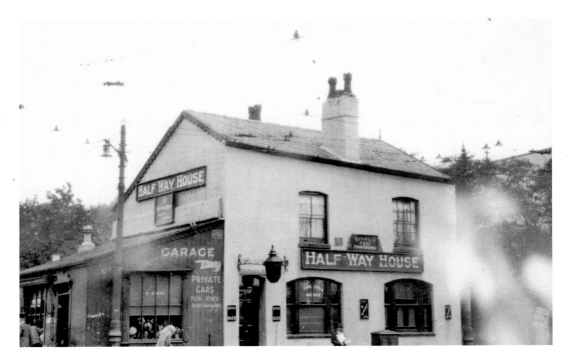

Halfway House, Bury Old Road, 1926

By 1926, the Halfway House had been built, and we can see the motor car has taken over as the hotel provides garaging and cars for hire. Originally, it was a much smaller building with access through a small door up three stone steps. Outside at the crossroads was a horse trough. The building is now a solicitor's office.

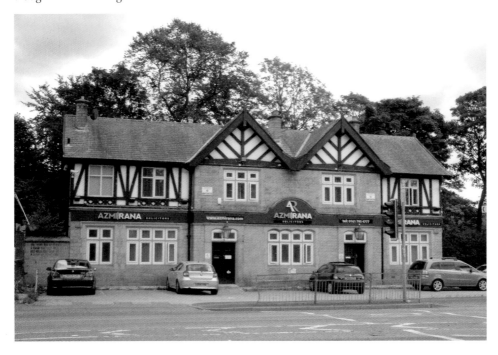

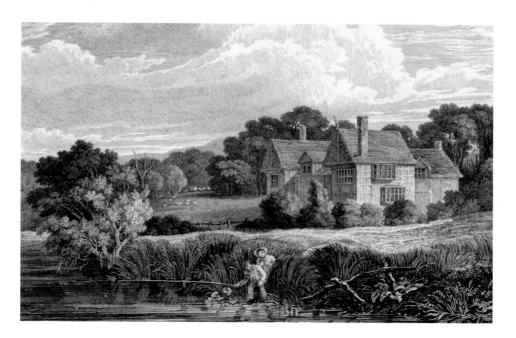

Crumpsall Hall, 1822

Crumpsall Hall stood in the area of Crumpsall Park. The site was originally a private residence with grounds surrounded by open fields. It was the residence of the Chetham family, and the birthplace of Sir Humphrey Chetham. The Chetham family were prosperous cloth merchants. His will provided for Chetham's hospital and library, opened in 1656, which later became the Chetham's School of Music. Chetham's Library, the oldest public library in the English-speaking world, is a superb memorial to a remarkable and public-spirited man. Since 1890, the area has been used as an open space for a variety of activities for local residents.

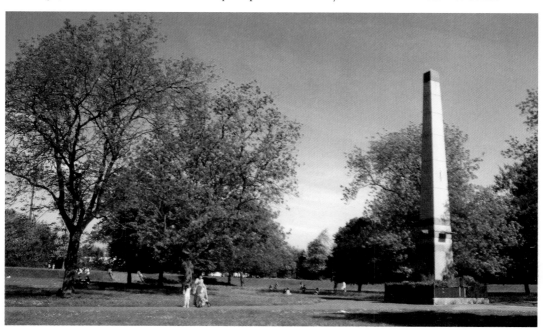

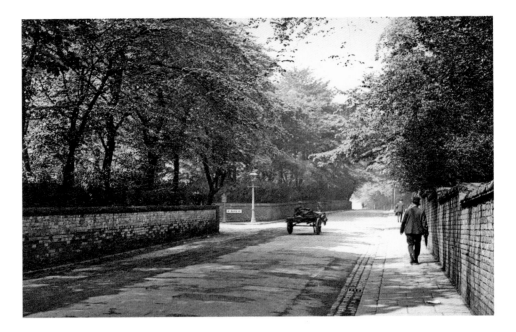

Crumpsall Lane, 1931

This is the corner of St Mary's Hall Road. The first church was built on the site in 1839, but was destroyed by fire after being struck by lightning on 4 January 1872. In 1874, a public meeting was held to raise funds to rebuild the church. The costs were estimated as £11,000 and it was stated that the rich dwellers of Wilton Polygon could easily raise the money. The later church was demolished around 1977. Nada Lodge, housing association flats, now occupies the land.

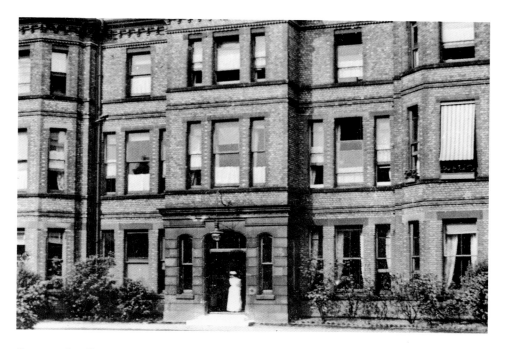

Crumpsall Infirmary Workhouse Hospital, 1910

Between 1855 and 1857, the Manchester Board of Guardians erected a new union workhouse here in Crumpsall. The workhouse, designed by Mills and Murgatroyd, could accommodate 1,660 inmates. The first inmates at Crumpsall in 1857 were able-bodied males who worked on the workhouse farm. So keen were they to provide good accommodation that the plans were sent to Florence Nightingale. Her suggestions for larger windows and better ventilation were approved. Now we see the busy main entrance to the hospital.

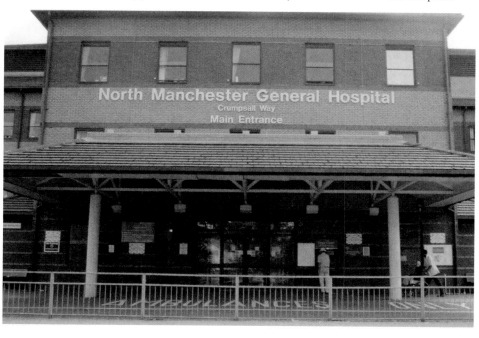

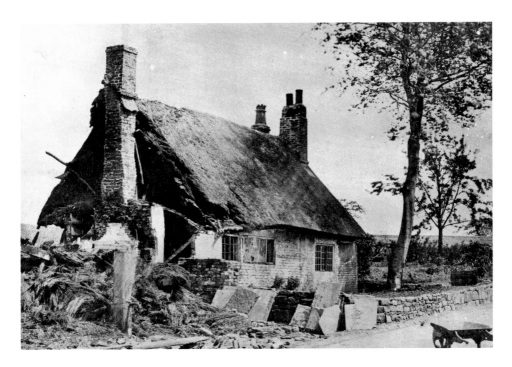

Springfield Cottage, 1920

The cottage looks sad even in 1920 when this photograph was taken. Springfield Hospital now stands near the spot. Bishop Oldham is sometimes said to have been born here, but the connection of his family with the township began much later than his time. He founded Manchester Grammar School in 1515. Below we have a view of the modern houses now on the site.

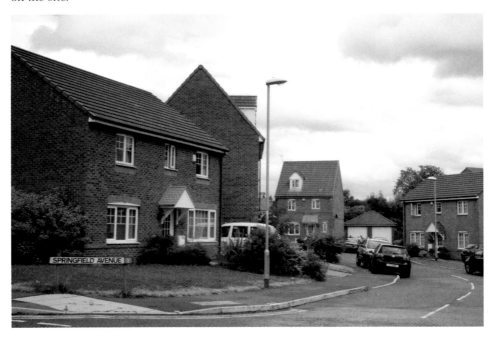

Middleton Road, 1939

These pretty cottages are on the west side of Middleton Road, at the corner of Moxley Road. They are shown on the 1848 Ordnance Survey map, with others north of the present Moxley Road shown as school houses. Good to see them still standing proudly today.

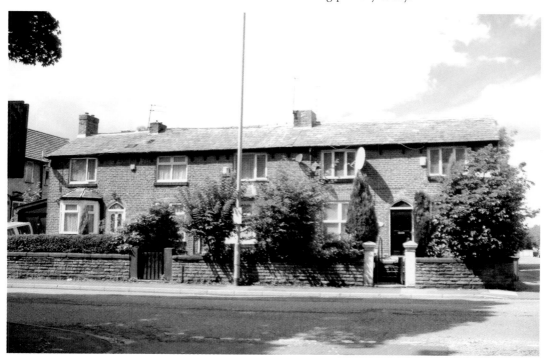

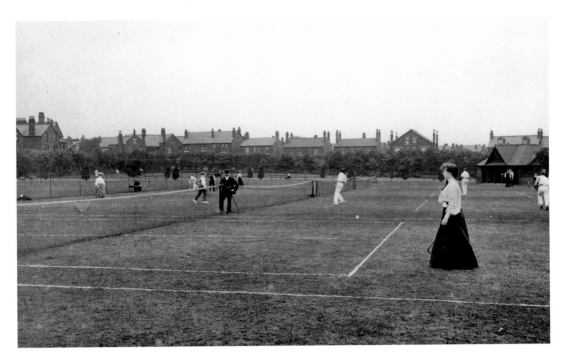

Crumpsall Park Tennis, 1907

This is a fine scene of mixed doubles in Crumpsall Park, the ladies modestly dressed. The park also boasted a bowling green. The umpire does not look like a man to argue with! Today, the park is dominated by mature trees, but is still a busy park and play area.

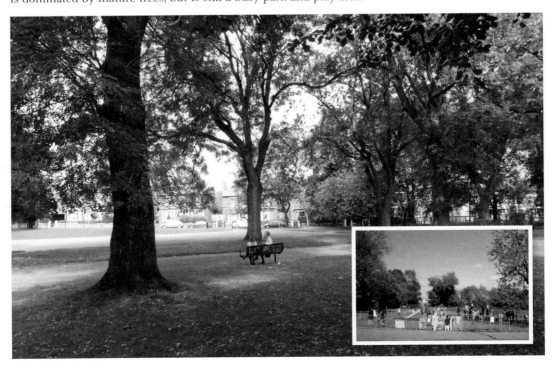

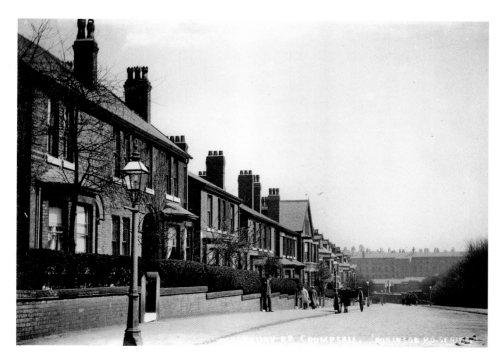

Westbury Road, 1910

What a pleasant road overlooking Crumpsall Park! Here we are looking down towards Springfield Hospital. Above we see the delivery man arriving on his horse and cart, and below we can see it is still a desirable place to live today.

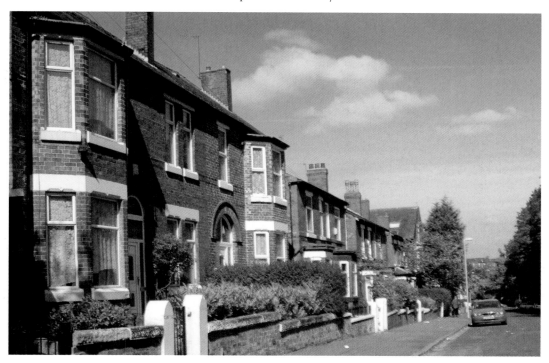

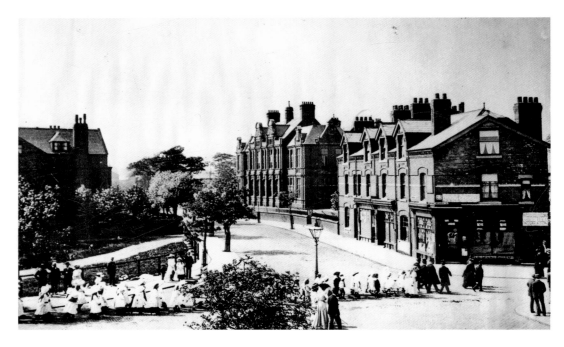

Crumpsall Lane, 1902

Whitsuntide was always an exciting time for Mancunians. Above we see the Whit Walks looking down Crumpsall Lane. In the centre is Crumpsall Lane Primary School, which still provides excellent education. They are walking, perhaps from the Methodist church, down Delaunays Road towards St Matthew's.

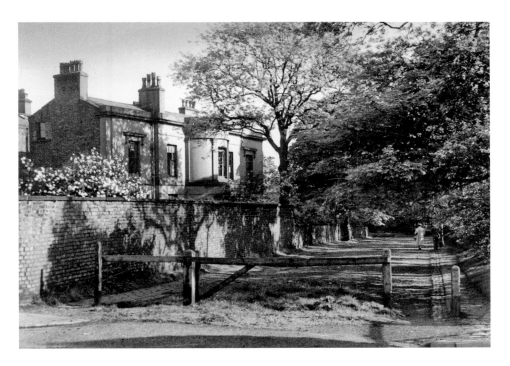

Wilton Polygon, 1940

What a beautiful spring scene this is! These fine houses in this photograph taken from Eaton Road were built for the prosperous merchants of Manchester. The houses were provided with coach houses and stables. It is surprising that these fine houses are no longer standing. Today, it is the site of the King David School.

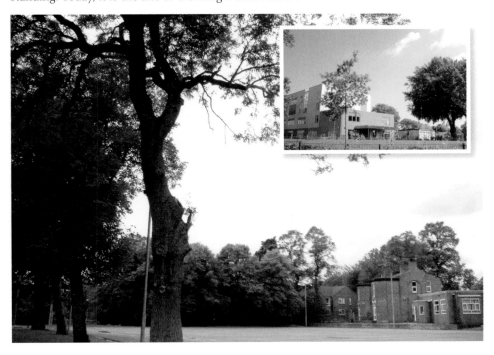

Blackley and Heaton Park

Blackley was once spelt 'Blakely', which explains its pronunciation today. The hamlet of Blakeley was mentioned in the Domesday Book. The name derives from the Anglo-Saxon 'dark wood', as Blackley was dominated by woodland, and remains of the forest still exist today. In 1598, the major landowner was Sir John Byron, an ancestor of the poet Lord Byron. The Heaton estate was inherited by Sir Thomas Egerton (later Earl of Wilton) in 1756. The parkland sits on high ground above Manchester. Blackley has a long involvement with the dyeing trade. In 1890, Blackley became part of the city, and six years later became part of the new township of North Manchester. Below we see Bacon's map of Blackley, 1907.

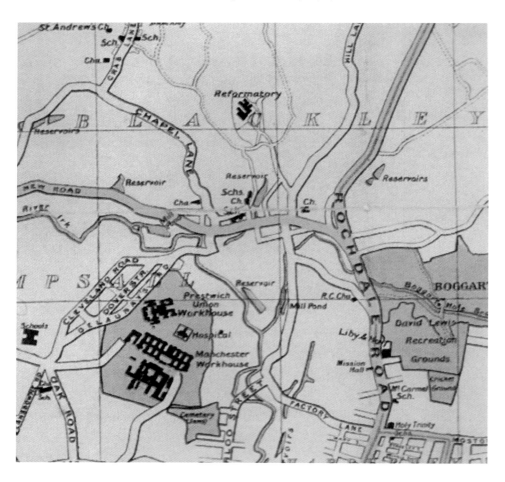

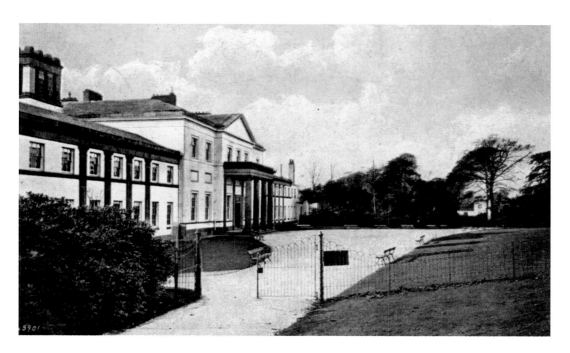

Heaton Hall North Side, 1903

In 1772, Sir Thomas Egerton built a new home in the park for himself and his new wife. Being young and wealthy, Sir Thomas employed the best, most fashionable architect of the time, James Wyatt. His house – Heaton Hall – and the other magnificent buildings that Wyatt and his family designed can still be seen around the park. The entrance into the house is on the north side. The frontage is quite plain, but the main façade and the main rooms are on the south side.

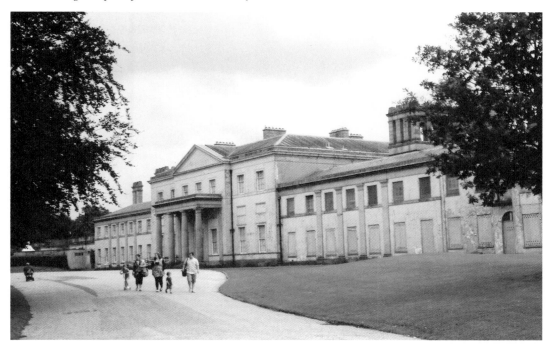

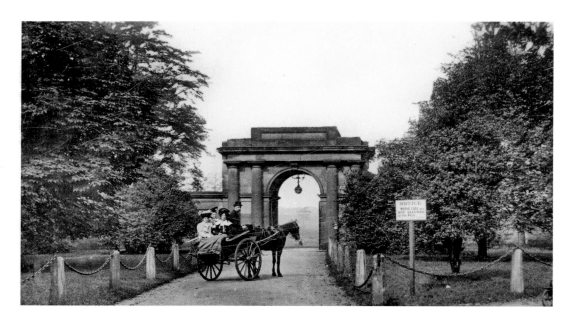

Heaton Park Grand Lodge, Sheepfoot Lane, 1903

Commissioned in 1807 by Sir Thomas Egerton, Grand Lodge was designed by Lewis Wyatt as an impressive main entrance to the park from the south. The lodge is built of sandstone as a large triumphal arch, and originally led onto one of the longest carriage drives to the house. It has two floors of accommodation. The construction of the lodge completed the enclosure of the park by a 10-foot-high boundary wall. It was refurbished as part of the millennium project and is now rented out to the public as short-stay accommodation. There is a memorial plaque here dedicated to the memory of the Manchester Pals, who trained in the park in 1914.

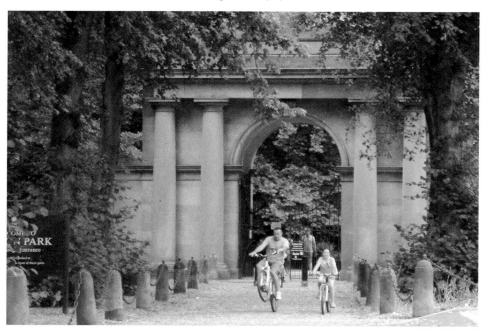

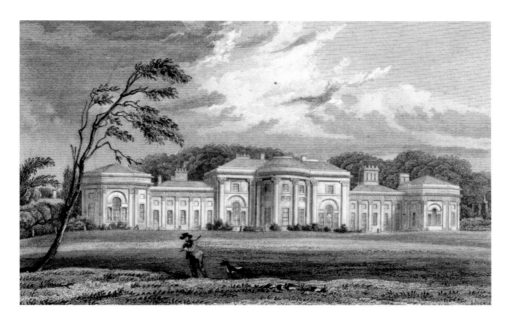

Heaton Park Hall, 1830

Heaton Park Hall is of a traditional Palladian design. It has a central block with a semi-circular bow, topped by a dome, flanked by colonnaded wings, ending in octagonal pavilions containing the kitchen and library. The main entertaining rooms are unusually ranged in line along the ground floor behind this façade. They are finely proportioned and exquisitely finished by the finest artists and craftsmen of the period. Sir Thomas' account books of the time show that Wyatt's neoclassical masterpiece was built in phases. The 2nd Earl of Wilton added the splendid chimneystacks and the orangery to Heaton Hall around 1820. Heaton Park remained in the Egerton family until 1902, when the 5th Earl of Wilton sold it to the Manchester Corporation for £230,000. The Corporation provided many public facilities, and it quickly became a popular people's park.

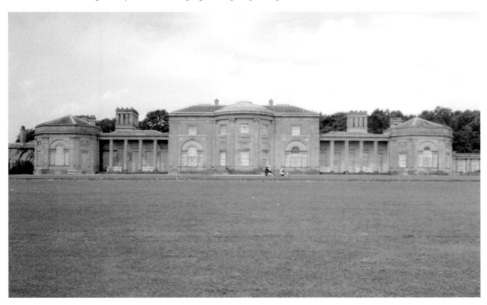

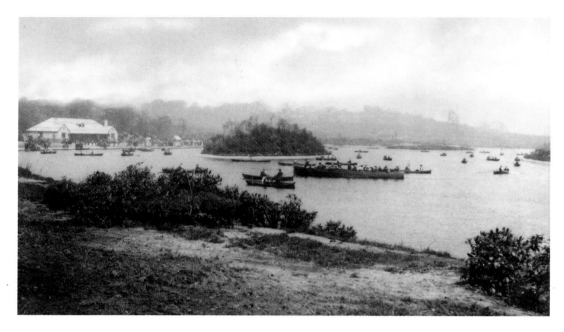

Heaton Park Lake, 1910

By 1913, there was a 12-acre boating lake. It was dug between 1908 and 1912 by unemployed labour, entirely by hand shovels and hand-pulled trucks. Between 1827 and 1839, the south end of the lake was the site of a racecourse. Today access to the lakeside is more difficult as the trees have matured.

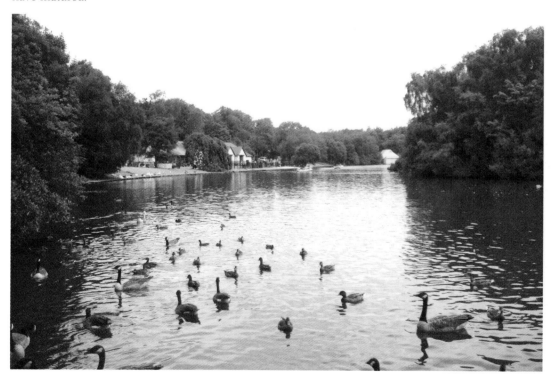

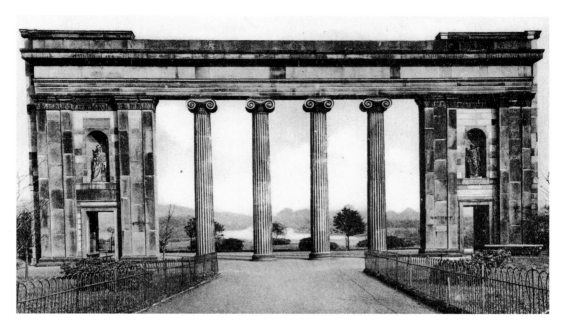

Heaton Park Corinthian Pillars, 1900

This fine portico, with four large ionic columns, was moved from King Street, Manchester, when the old town hall was demolished in 1912. It was designed by Francis Goodwin. It was preserved and rebuilt at the southern end of the lake. The site is now full of trees, so it has lost its grandeur and it is difficult to see the lake beyond.

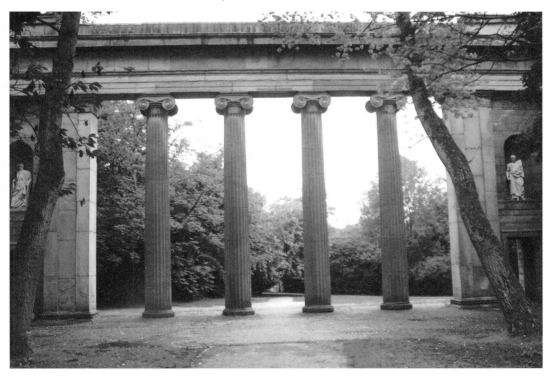

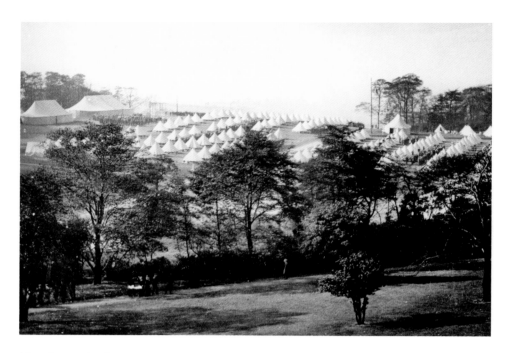

Manchester Regiment, 1915
During the First World War, Heaton Park was used for billeting and training thousands of soldiers from the Manchester Regiment. There was even a mock-up of the trench system on the Western Front, built where the pitch-and-putt course is today.

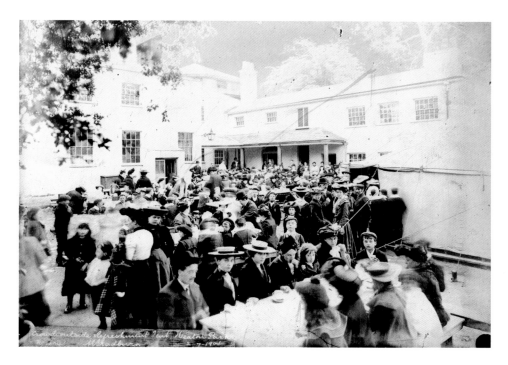

Heaton Park Refreshments, 1904

There was a stylish Edwardian tea room at the west end of the hall. It must have been very busy, as a tent was erected to cater for the huge crowd. Later the stable block accommodated the café, but here we see a sign of the times: only Main café is by the lake today.

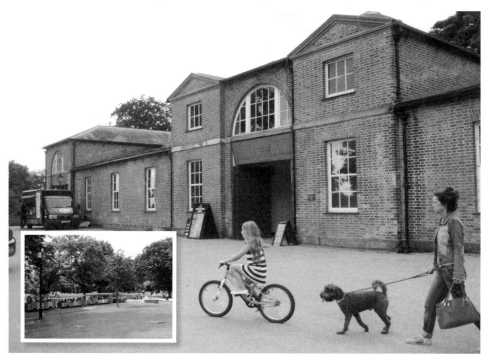

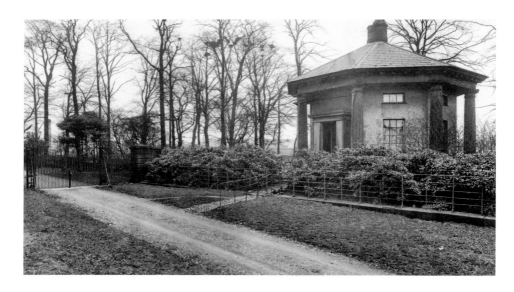

Heaton Park Smithy Lodge, 1902

Sir Thomas Egerton was a man of fashion and taste, and the design of Smithy Lodge shows that he embraced the change towards the romantic landscape. It is the earliest gatehouse into the park and built in an unusual octagonal shape. It is thought that this too was designed by Lewis Wyatt in 1806, as a cottage to be viewed from the house in a romantic, rural setting. Its name derives from a group of blacksmith's shops set close by on Middleton Road, which are now demolished. In 1913, the park's new golf course manager appointed a professional, Sid Ball, who lived in the tiny house with his wife and eight children. Both lodges were refurbished in the Heritage Lottery Fund restoration of the historic features of the park in the late 1990s.

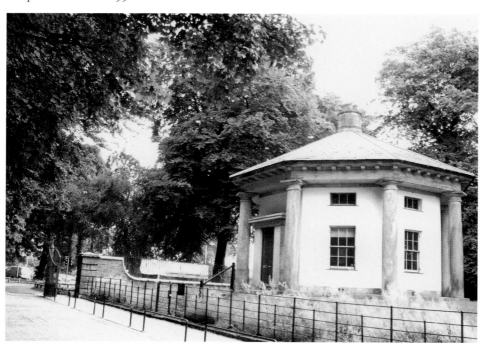

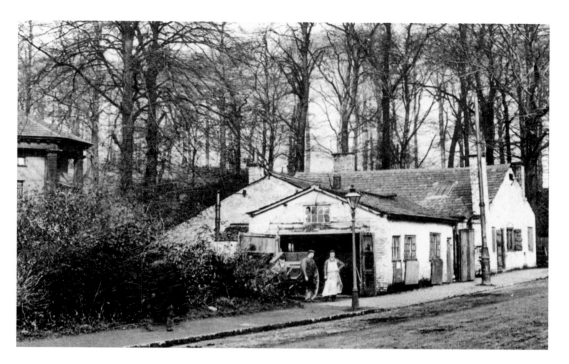

Heaton Park Three Arrows, 1898

Here we see the smithy that gave Smithy Lodge its name. When the park was sold to the corporation, it saw the demise of the old blacksmiths. The building is long gone. In the modern photograph we see the Three Arrows further down. I'm not sure when it was originally built, but the pub is shown on the map of 1850.

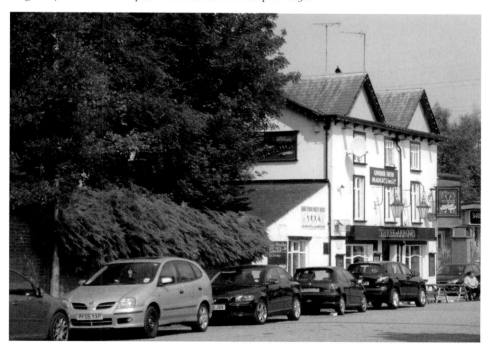

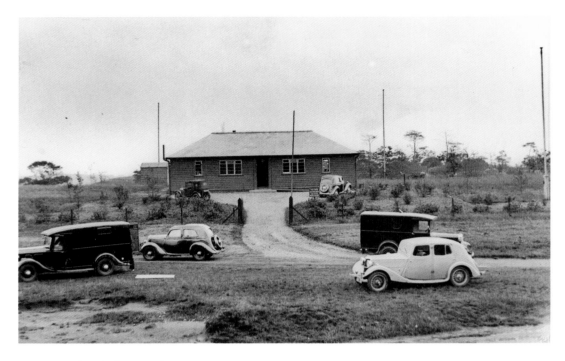

Heaton Park Wireless Station, 1938
This photograph was taken just before the war, and no doubt the wireless station was invaluable in war time. The original wireless station was replaced in 1964 by this massive telecommunications tower. It reminds me of a space rocket, with its sleek concrete shaft and contraptions around the top.

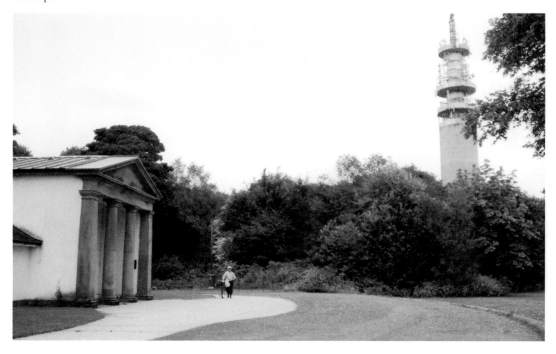

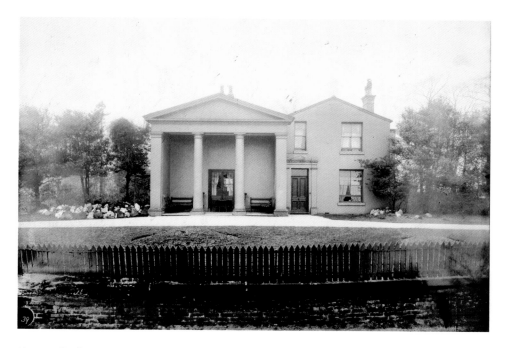

Heaton Park Dower House, 1902

Originally called poultry house, this plain brick building was transformed with a decorative columned façade in 1803. In front of the house is the ha ha. In this photograph it is fenced, but this was a feature used in landscape garden design to keep grazing livestock out of a garden, while providing an uninterrupted view from the house. It is now the home of the Manchester & District Beekeepers' Association, and is furnished with an observation hive, equipment and displays, with an apiary in the garden behind the house.

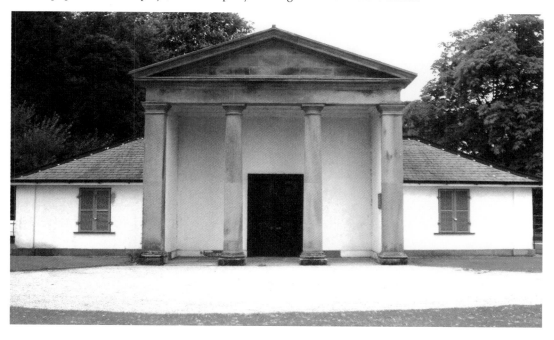

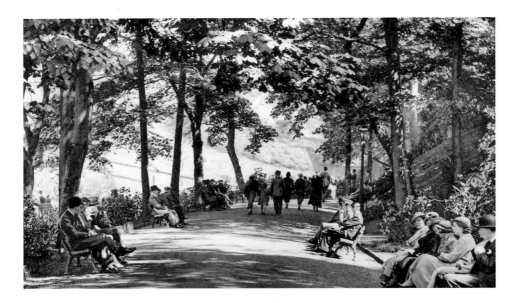

Boggart Hole Clough, 1935

What a busy scene! The park had an open-air theatre, and on Sunday afternoons the park rang out to the sound of brass band concerts. The park was the venue for mass meetings. In 1896, Emmeline Pankhurst and Keir Hardie addressed an Independent Labour Party meeting of up to 50,000 people. This led to locals complaining that the Independent Labour Party was destroying the tranquility of the park. For generations, Boggart Hole Clough has been an adventure playground and country park for local children. In 1911, the area was purchased by Manchester Corporation and gradually transformed into a magnificent country park, with a boating lake, running tracks, cafés and open-air theatre and, of course, its famous penguins!

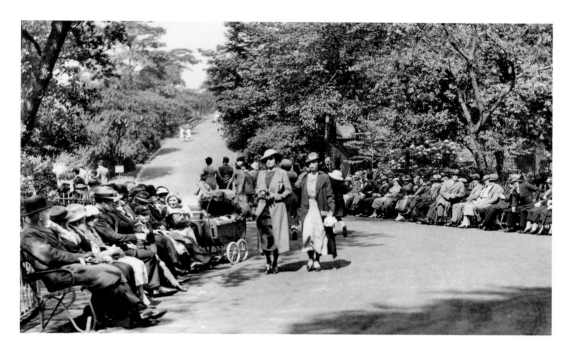

Boggart Hole Clough, 1931

Crowds flocked to the clough in their Sunday best. Here we see Clough Bottom, and to the left was the busy refreshment room. This area is known locally as the valley, and it has an ancient history. On early maps it is referred to as Easton Grange, and it is believed this was an early monastic farmstead. It has often been claimed that the clough is haunted by a boggart, a mischievous spirit.

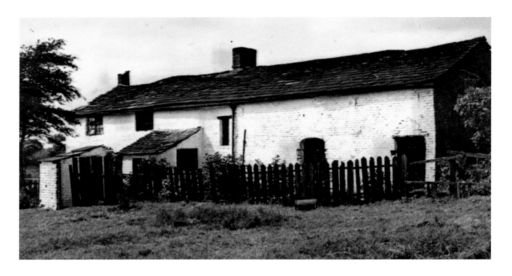

Boggart Hole Clough Lumb Farm, 1930
Lumb stood at the top of the clough. On the 1841 census, Samuel Wharmby lived here with his wife, Elizabeth, and daughter, Sarah. Today, we see fields looking towards Charlestown Road. Nearby was Bowker Hall. It has also been suggested that 'Boggart' is a local dialect pronunciation of Bowker. The Bowkers were a prominent local family who lived in Bowker Hall, which stood where North Manchester Girls School now stands, overlooking the clough.

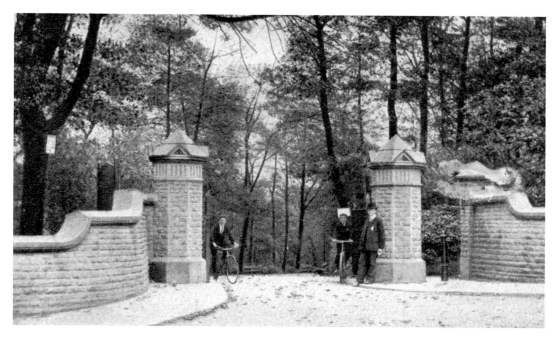

Entrance to Boggart Hole Clough, 1908
The entrance on Valentine Brow. Boggart Hole Clough was ancient woodland referred to as Grelley's deer park. The land was granted to Thomas Grelley by King Henry III in 1249. It still retains its wild atmosphere today, with its picturesque cloughs, steep ravines and sloping gullies. Clough is local dialect for a steep-sided wooded valley.

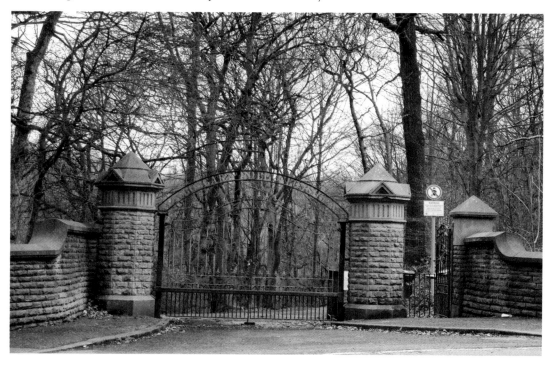

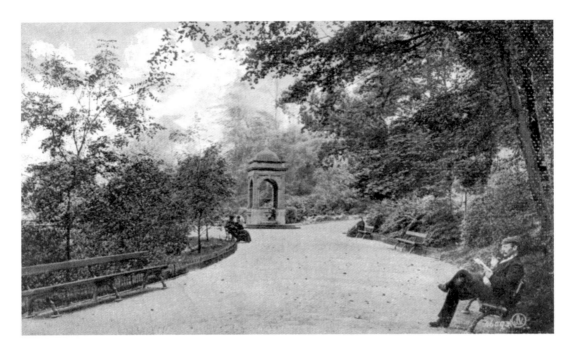

Boggart Hole Clough, 1900

This beautiful fountain was down in the valley near to the refreshment room, now long gone. Just up the hill still stands the Angel Hill war memorial, a magnificent structure topped by a bronze statue of a Winged Victory. What a wonderful tribute to the men of the First World War.

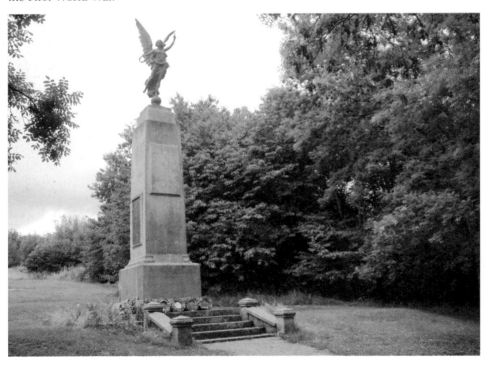

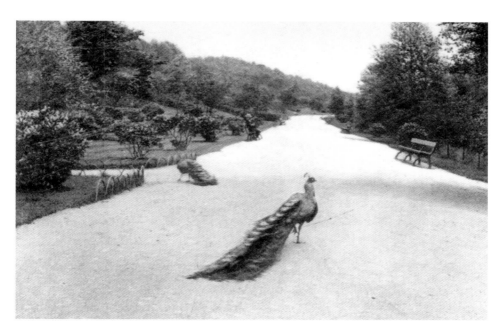

Boggart Hole Clough, Broadwalk Blackley, 1907

The clough was famed for its peacocks. Here we see two beauties on the broadwalk in 1907, looking up towards the lake. The broadwalk was laid out by the corporation in the early 1900s. This is still a popular walk today, but sadly there are no peacocks to admire.

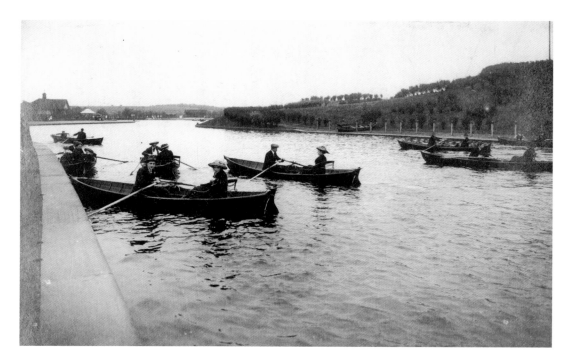

Boggart Hole Clough Lake, 1900
A lovely picture of the lake and the rowing boats for hire. Those fine ladies' hats must not get wet! In the background is the café, which is still open today. To the side is a fishing pond. Still a happy scene and a popular resting spot for the Canada geese.

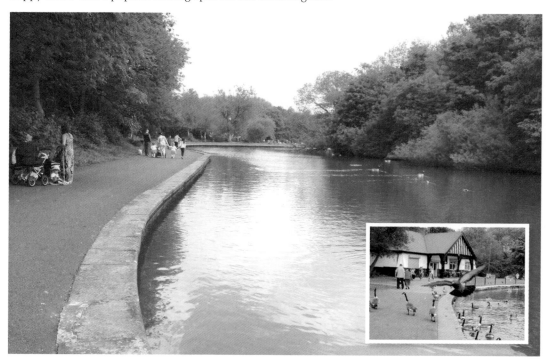

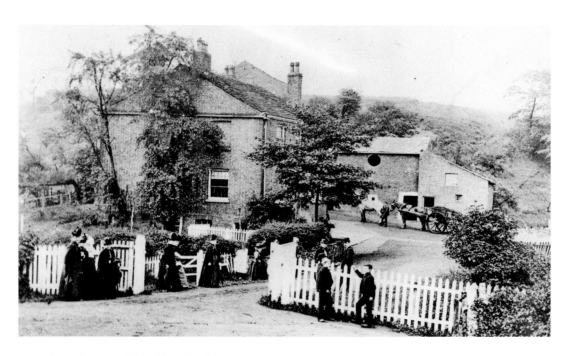

Farm Boggart Hole Clough, 1890

What a busy scene! The farm was converted into a refreshment room, which was always a busy spot during summer holidays. The clough was the subject of a letter to the home secretary in 1896, in which the local people complained that the public meetings were disturbing the wildlife, and farmers came to resent the general public gathering on their grazing land. The buildings are now demolished and the area has been taken over by mature trees.

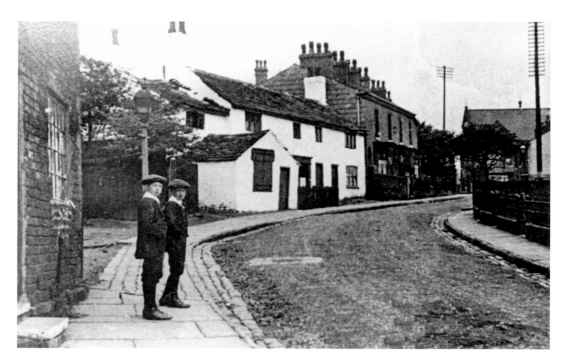

Crab Lane, 1908

Looking at a map of Higher Blackley in the 1920s, we see the Zion chapel, St Andrew's church and school, and St Peter's Mission church at Munn Lane. What a busy village this must have been! How fine these boys look in their breeches, jackets and peaked caps. We can see the Methodist New Connexion chapel, which has since been demolished.

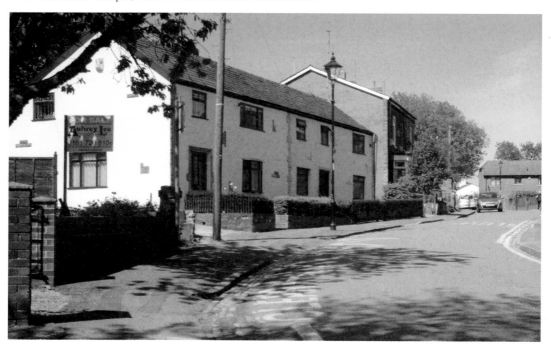

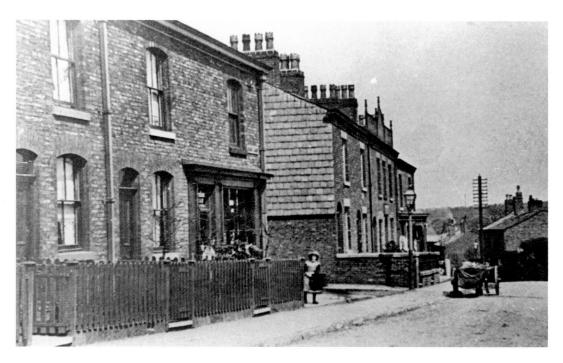

Blackley Crab Lane, 1908
A view looking down Crab Lane towards The Flying Horse, and the children are intrigued by the photographer. Even today, Crab Lane has maintained its village atmosphere. To the left is St Andrew's church, built in 1874.

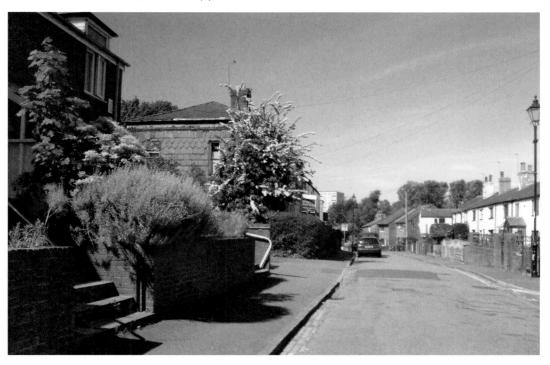

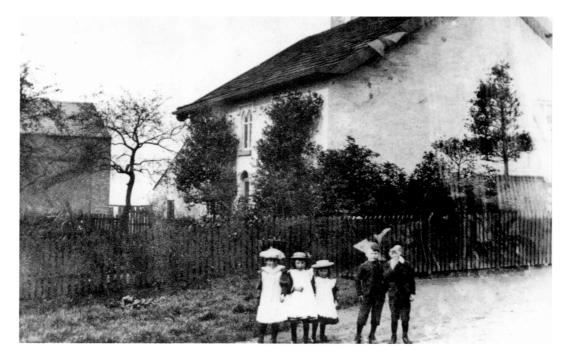

Foxholes Farm, 1900

This farm stood near to the entrance of Blackley cemetery, near Longhurst Road. This is a charming photograph of the children. The farm was probably demolished when the cemetery was laid out. The 1861 census shows Charles Jackson, a farmer of 40 acres, with his wife, Sarah, their two daughters, one son and one servant.

Blackley General View, Crumpsall Hospital Beyond, 1972
A lovely view of the hospital standing high above the valley. To the right we can see Blackley village and Hexagon Tower. The modern shot shows the modern housing in Lower Crumpsall and Blackley village. In the distance we can see the telecommunications tower in Heaton Park.

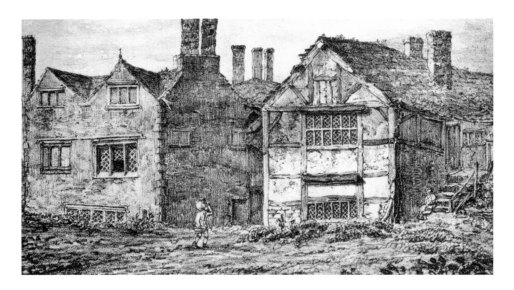

Blackley Hall, 1821

The hall was built around 1547 and was a spacious, black-and-white, half-timbered mansion. Another wing was erected probably around the beginning of the seventeenth century. It was situated around 150 yards from the junction of Rochdale Road, near to Middleton Old Road. Early in the seventeenth century, James Assheton of Chadderton acquired Blackley Hall and sold it to Sir Richard Assheton of Middleton. Around 1760, a schoolmaster named Nicholson rented a large room in Blackley Hall from the Scholes family and ran a school for 150 pupils. He reported a ghost, the wife of Old Shay, who was murdered, walked the deserted rooms at night accompanied by a black dog. The hall was demolished in 1815. Here we see the junction of Market Street and the New White Lion.

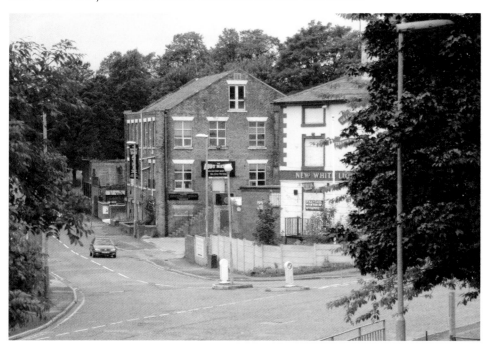

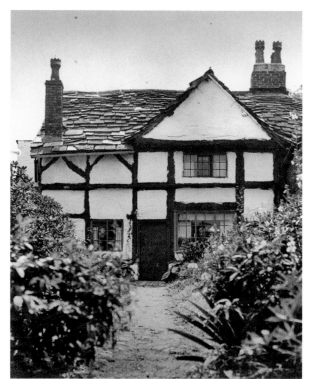

Plane Tree Cottages, 1926
These lovely cottages stood on
Heaton Park Road near the bend.
They were demolished in 1938. The
lane was originally named Hollow
Lane. This area was known as 'Top
of the Arbor', and it lost its rural
nature when Victoria Avenue was
laid out. The area was chosen as an
early housing experiment. Houses
'fit for heroes' were built in 1919.
In the modern photograph we see
the Park View pub on the bend and
beyond towards Rhodes.

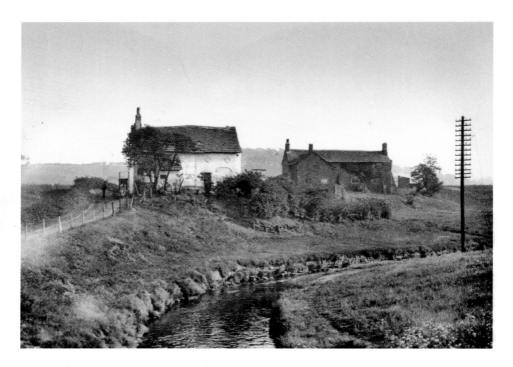

New Bridge Cottages, 1901

These cottages stood at the end of Heaton Park Road. The area is now dominated by Sainsbury's. In the 1891 census, we see John Jackson living here with his wife, Dorothy, and son, George. This must have been the family of C. S. Jackson, who was born here in 1908 and wrote his interesting memories of Higher Blackley in *Down Hollow Lane*.

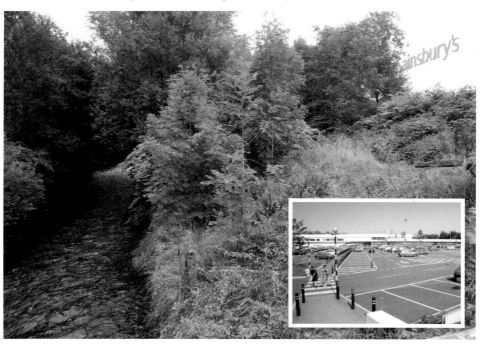

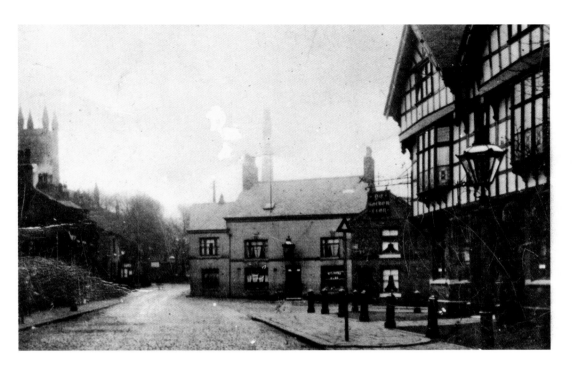

Old Market Street, 1900

This area was the centre of the ancient village of Blackley. We see Ye Golden Lion on the corner. The Lion & Lamb opposite has gone. St Peter's church is on the left. A chapel existed here as early as 1611, possibly to serve the residents of Blackley Hall. The present church, built in 1844, is set further back on a grassy mound.

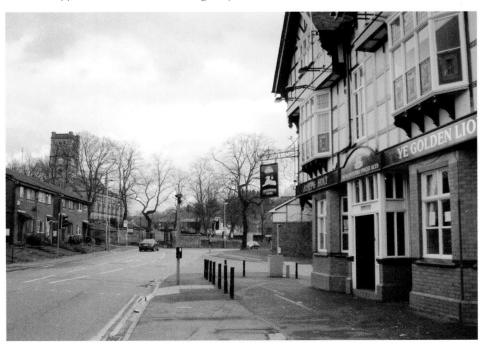

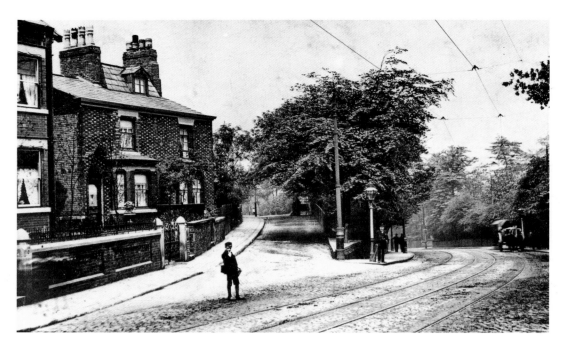

Valentine Brow, 1910

The bottom of the hill was known as Valentines, giving this part of Rochdale Road its name. This view of Valentine Brow looks across to Old Road, towards Mount Carmel. This fine parish began in a humble way in 1851, meaning that it is almost as old as Salford diocese. The church of Our Lady of Mount Carmel was first built in 1855, and was replaced by a larger one in 1908. Opposite was the convent of the Good Shepherd, and nearby was Blackley Library.

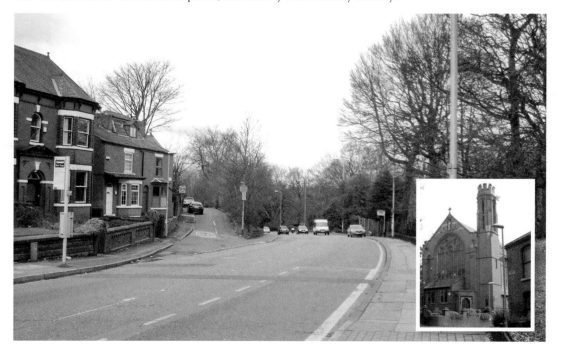

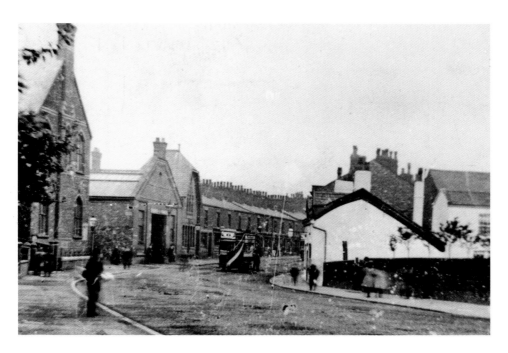

Blackley, Rochdale Road, 1910

The first public house here was named the Printers Arms, later renamed the Farmyard (right). The licensee was John Barnes and he gave his name to the area Barnes Green. During Blackley Wakes, horse racing was held between Barnes Green and Hall Street. In the modern shot we see Harpurhey Swimming Baths on the left, built around 1910 by Henry Price, Manchester's first city architect. The baths were closed to the public in 2001.

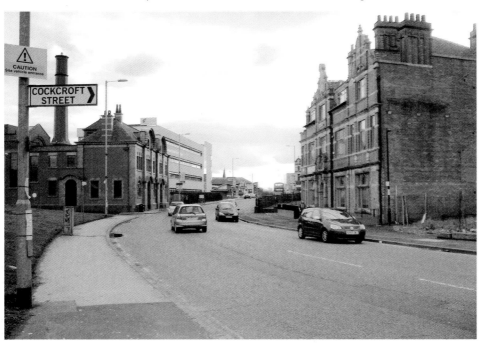

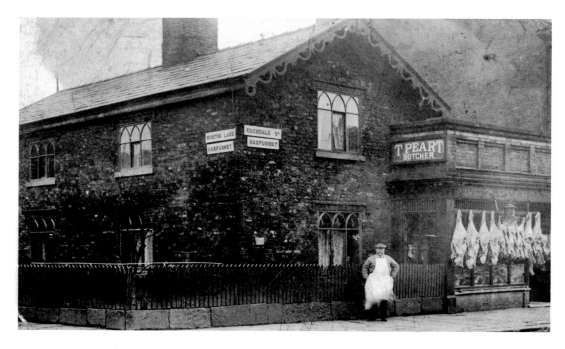

Moston Lane, Rochdale Road, 1920

The junction here was known as Three Lane Ends up to 1820, and later as Barnes Green. How very different it is now! Asda dominates the crossroads, and opposite is the fine North City Library and North Manchester Sixth Form College.

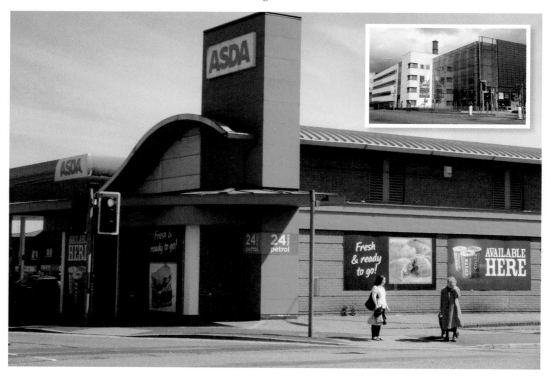

Moston Lane, Cobden Street, 1907

Cobden Street is where I was born. I attended Holy Trinity and the church holds many happy memories. The church was the centre of the community, offering social events for all ages. The parish of Holy Trinity was formed in 1900 to meet the needs of a growing population. In 1907, we see the temporary wooden building, now replaced by a fine brick building. I remember the greengrocer we see on the right, but by the 1950s, Dunn's grocers had become Kime's chemist.

Moston

Moston or, as it was originally named, Mostun, was a wild and remote place. The land was peat bog and barren. It may then come as a surprise to many Mostonians that it boasted as many as five halls. Moston Hall, Great Nuthurst Hall, Little Nuthurst Hall, Lightbowne Hall and Hough Hall, which we can still see today. The early story includes Ralph de Moston of Moston Hall, the Radcliffes and the Shacklocks. Since 1547, the Bowker family had owned part of Moston. Bowker comes from 'bowking', which is the washing and bleaching of linen, and the people of Moston were earning a living from bleaching linen yarn as early as 1595. Moston became a place specialising in the dyeing and bleaching processes. Coal mining was also a feature of life in Moston. As early as 1613, James Chetham of Nuthurst mentioned a coal mine in his will. By 1939, production at Moston pit was 176,000 tons, gradually reducing until closure in 1950, when industry in Moston was disappearing.

In an ironic twist of fate, the world's first digital computer system was built at Ferranti in Moston in 1950, an achievement that heralded the beginning of a new industrial revolution. Here we see The Museum, the early cottage inn, at Street Fold.

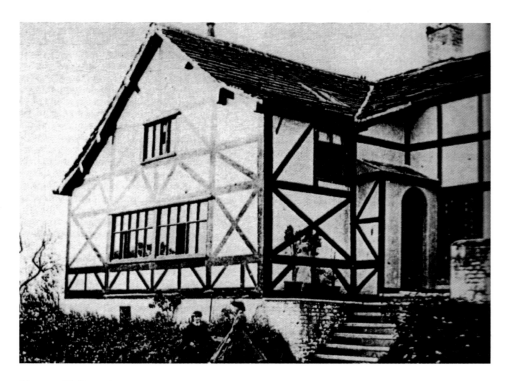

Moston Hall, *c.* **1875**

The oldest known dwelling in Moston. The Chethams purchased the hall from the Shacklock family in 1663. The earliest census of 1841 shows John Slingsby, farmer and cattle dealer, his wife, four children and five servants living in Moston Hall. It stood derelict from the end of nineteenth century. The last known resident was pig farmer Piggy Dixon. The hall stood behind the Alexian Brothers Nursing Home in Broadhurst Park. In the modern photo we can still see the nursing home on the right.

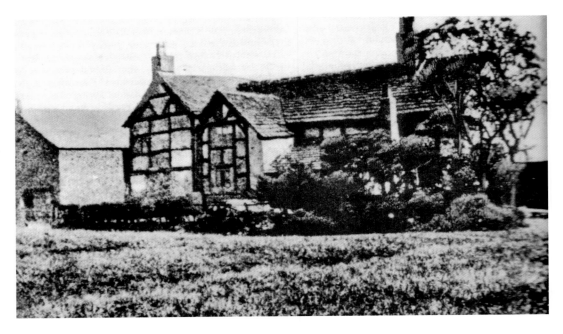

Great Nuthurst Hall, c. 1880

The hall stood near to the railway line on Nuthurst Road. Thomas Chetham obtained the tenure of the hall in 1515. During the Civil War, the house was owned by Thomas Chetham, who fought for the parliamentary cause in the defence of Manchester in 1642. The hall passed to the Hilton family by marriage, T. W. Legh Hilton being the last of the line to live at the hall. The census of 1871 shows that Samuel Shawcross occupied the hall and farmed 30 acres. By 1893, the hall had vanished from the Ordnance Survey map.

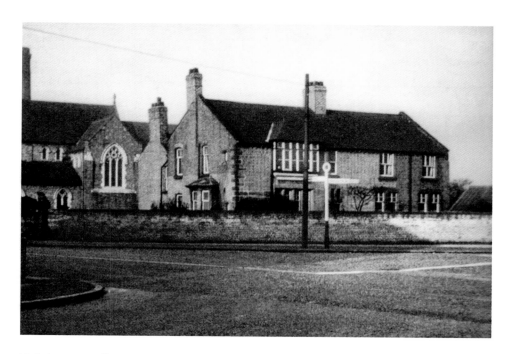

Lightbowne Hall, 1954

The hall stood on the corner of Kenyon Lane and Lightbowne Road, next to St Luke's church. The original building was the home of the Jepson family, and James Lightbowne acquired the property by marriage. The hall was built around 1649 and remained for 300 years. Oliver Cromwell is reputed to have visited the hall during the Civil War. The hall was demolished in 1965, and the rectory to the church stands on the land today.

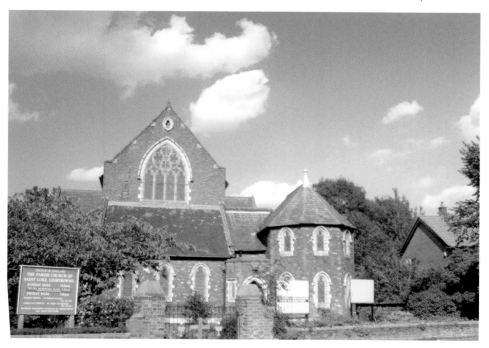

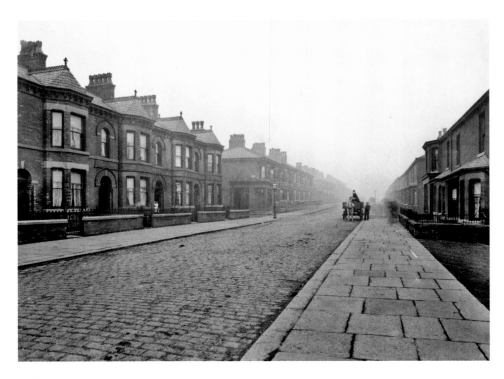

Lightbowne Road, 1900

Lightbowne Road is shown on early maps leading to Lightbowne Hall. The Lightbowne family came from Bolton and became a leading family in the story of Moston. A Roman pavement was found near Lightbowne Hall. Many of the fine terraced villas still stand today.

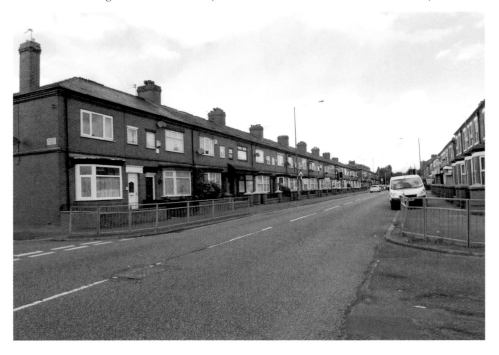

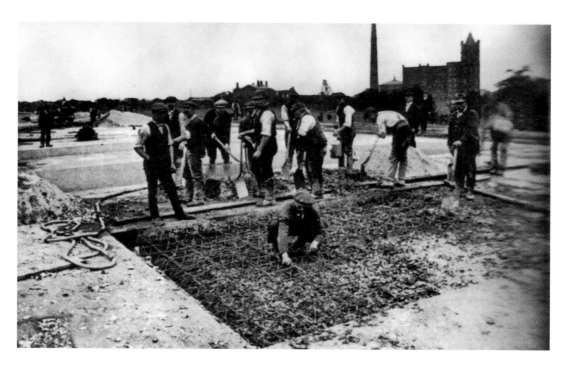

Lightbowne Road, Moston Mill, 1922

This is a view of the building of the new section of Lightbowne Road, with the mill in the background. Moston Mill was a cotton-spinning mill, built as late as 1910, but by then the cotton trade in Manchester was in decline. The fine building has recently been demolished to be replaced by modern houses.

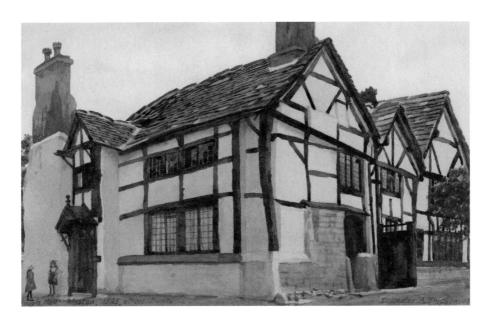

Hough Hall, 1925

The only remaining ancient hall still standing in Moston. A two-storey, timber and plaster Tudor farmhouse. Hough Hall was the residence of the Hough (Halgh) family. Capt. Robert Hough took the King's side in the Civil War, and had his estate sequestered. It was purchased in 1685 by James Lightbowne, and soon afterwards passed to the Minshulls. Roger Aytoun acquired the hall by marriage. He was drunk on his wedding day, deserted his wife within the week, and squandered her fortune. By 1880, it was the home of the Ward family, successful textile merchants, who restored the house. It has since been a doctor's surgery and a coal yard. Now it stands forlornly, hoping for someone to restore it to its former glory.

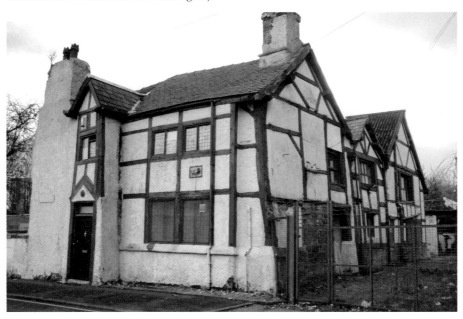

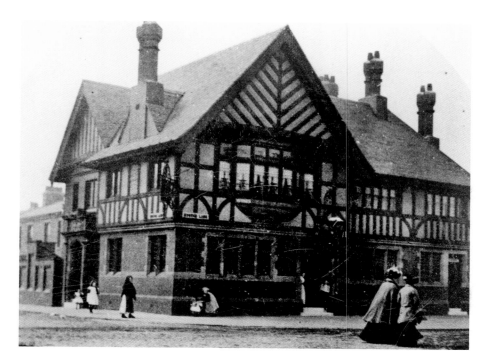

Ben Brierley, 1890

It stands on site of two old cottages knocked together and known as the long vault. Ben Brierley was a famous dialect poet who was born in Failsworth but lived at No. 17 Hall Street, Moston. He died in 1896, and was buried at Harpurhey Cemetery. In 1898, a statue was unveiled in Queen's Park, Manchester, in his memory. Brierley's autobiography, *Home Memories*, was published in 1886. They are written largely in the dialect of South Lancashire and, with their rich humour and unforced pathos, they provide a valuable picture of the life of working-class people in the period 1825–90.

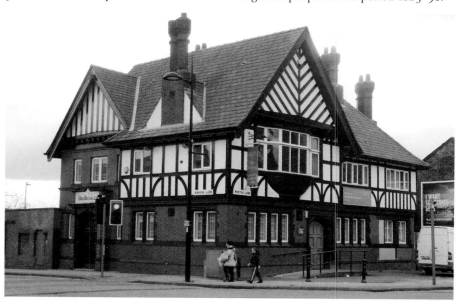

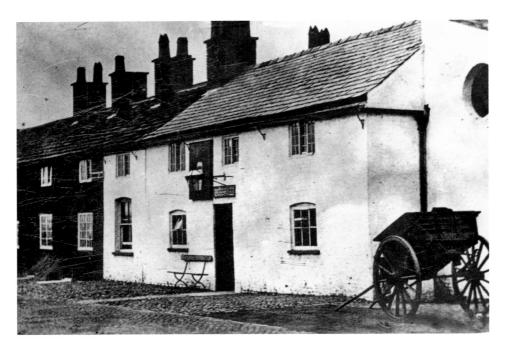

Blue Bell Inn, 1895

This was the first licensed public house in Moston, and was originally an old cottage inn. It was the centre of country life, being the venue for the old rush cart procession. In 1800, the Lightbowne estate was sold to Samuel Taylor. This sale included the Blue Bell Inn. The lane here was called Clegg's Lane, and further up to Shakliffe Green it was called Nunfield Lane. We can now see the much grander public house.

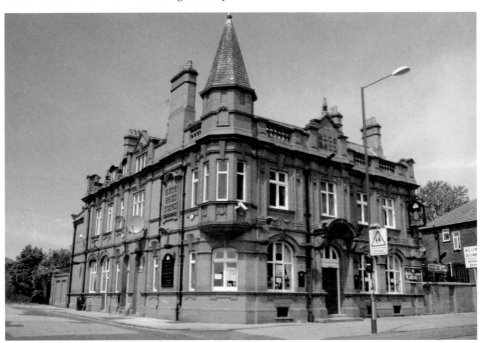

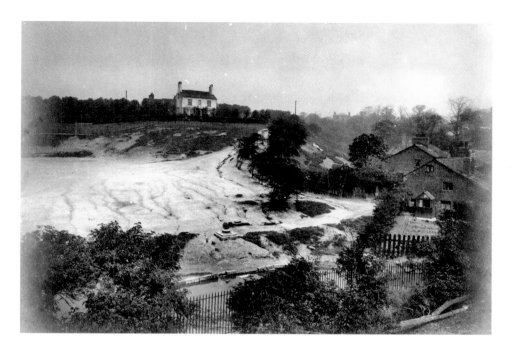

Moston Bottoms, 1900

Sometimes known as Moss Brook. The photograph is looking towards Church Lane. The three cottages on Moston Bottoms were once owned by Moston Hall. During the 1950s and 1960s, the famous Salford painter L. S. Lowry was a regular visitor to Moston Bottoms. It is now beautifully landscaped and cared for by the Forestry Commission. Local folklore dictates that a lady who lived here created her own informal animal sanctuary. It is now the home of Manchester and Cheshire dogs' home.

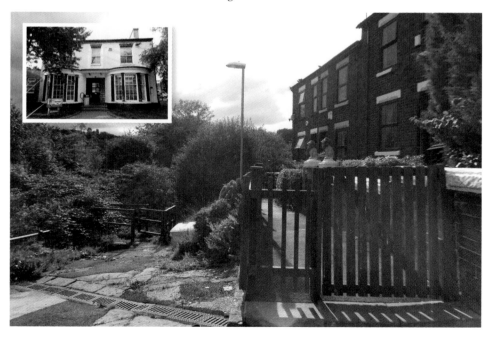

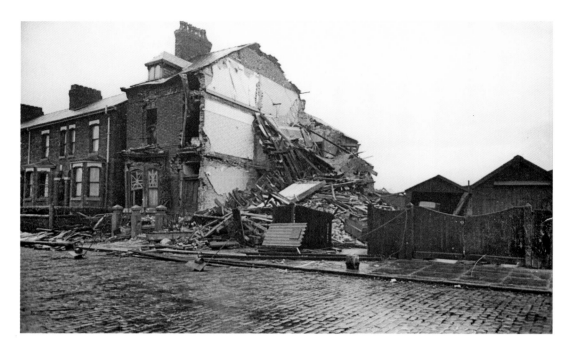

Ashley Lane, 1940

Ashley Lane was originally known as Brass Knob Street, and I am yet to discover why. Here we see the bomb damage in 1940. Two houses were destroyed, and St John's church opposite was also damaged. The target for the bombing was A. V. Roe's factory, where the Lancaster bomber was being manufactured. Pleasant houses have now replaced the bomb damage.

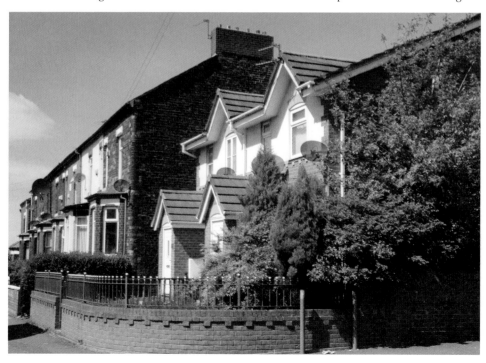

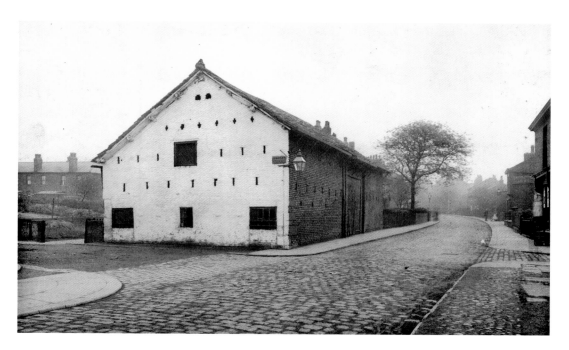

Moston Lane, Between Melbourne Street and Goodman Street, 1898
Melbourne Street looking up Sankey's Brow. On the corner of Clough Road was a grand house, the home of Doctor Sankey. Perhaps that's how the hill got its name? We can still see the old Ideal Billiard Hall, built in 1929, later Blundell's furniture shop. Opposite was Farrington's garage. Nearby was St George's Presbyterian church, built in 1882. It was a very active church until its closure in 1974, when many worshippers transferred to Street Fold Methodist.

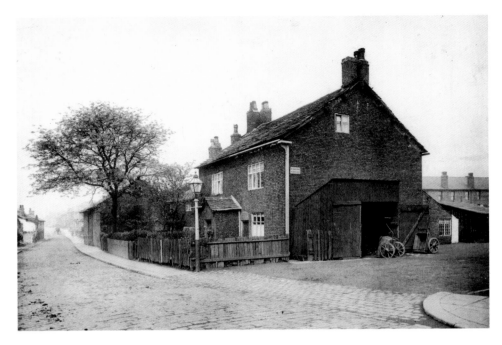

Moston Lane, Between Melbourne Street and Goodman Street, 1896
Looking down Moston Lane. This was the site of Blackley parish workhouse, and beyond was the lunatic asylum. The workhouse was still here in 1848 and remained in use until Manchester workhouse opened in Crumpsall in 1855. It was later converted for use as a school for the union's pauper boys. We can just about see the Old Loom in both views. The name comes from the nickname of Samuel Taylor, the owner of the original cottage inn.

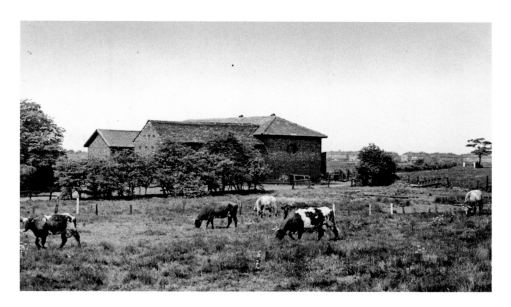

Moss House Farm, 1937

Moss House stood on Charlestown Road near to the junction of Moston Lane. This area was known as Fourways, once home to the cinema, which has now gone. North Manchester Grammar School for Boys was opened here in June 1931. In 1948, Mr R. M. Sibson was appointed headmaster. He was determined to increase the sixth-form and started a tradition of entering pupils for Oxford and Cambridge Universities. He achieved great success. In 1966, the school became comprehensive and was amalgamated with Moss House School, which stood nearby. As we can see, the Manchester Creative and Media Academy now stands proudly on the site.

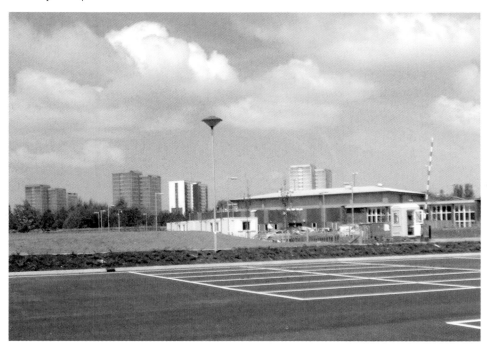

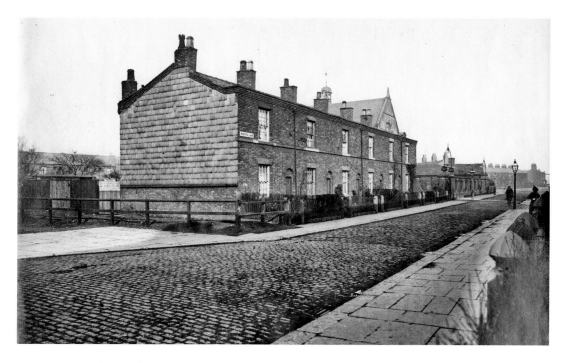

Moston Lane, Ebsworth Street, 1907

Here we see Moston Lane looking towards the Simpson Memorial and the cottages at Ben Brierley, which still stand today. Now named Ebsworth Street, it was originally Elizabeth Street. The houses are long gone and now we see a busy shopping street.

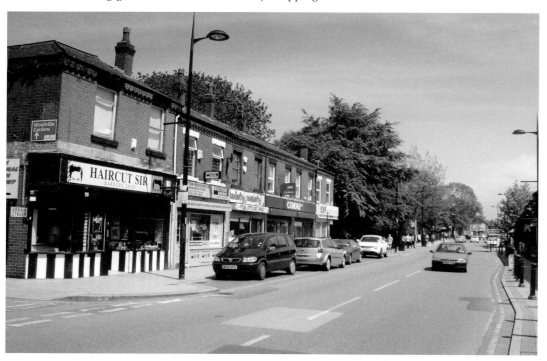

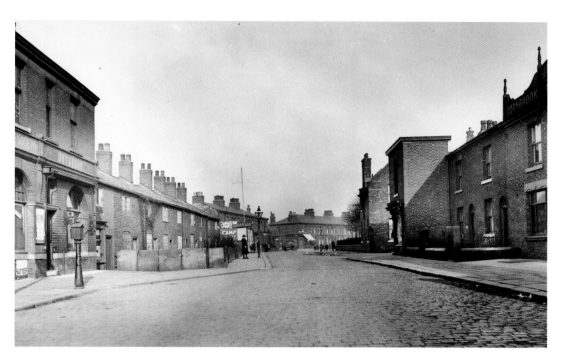

Moston Lane from Clough Road, 1928

Looking up towards the school, we can see the small cottages that housed fustian cutters employed by the Ward family. This area had a history of textile cottage industry. (Fustian was a tough linen and cotton fabric.) We can just see the Mowers Arms, named after a mowing contest 150 years ago between owner Jack Sidebottom and Tom Holland.

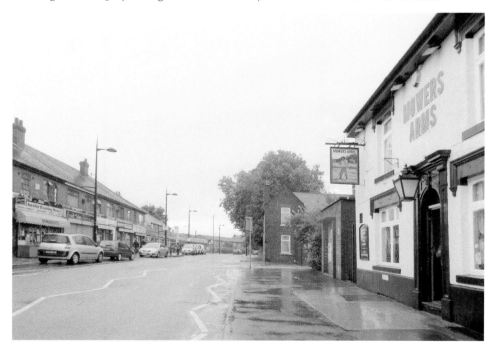

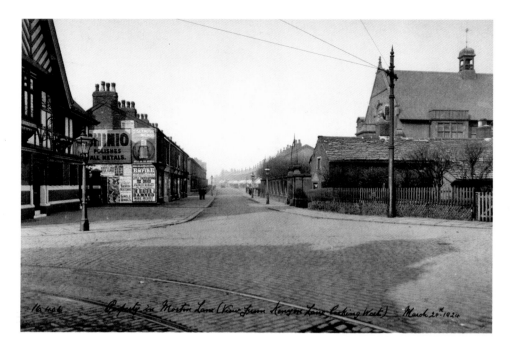

Moston Lane from Kenyon Lane, 1924

This section of Moston Lane was a thriving, bustling thoroughfare. Opposite the Ben Brierley was the large Co-op department store. Down the lane was a large variety of busy shops. I remember Gosling's the fishmonger, Frank Smith's outfitter's, Timpson's shoe shop and many more. The Ben Brierley was a busy transport hub. From my school days, I remember fondly Inspector Mountfield ensuring buses ran on time, and that the many children travelling to school had their tickets and passes.

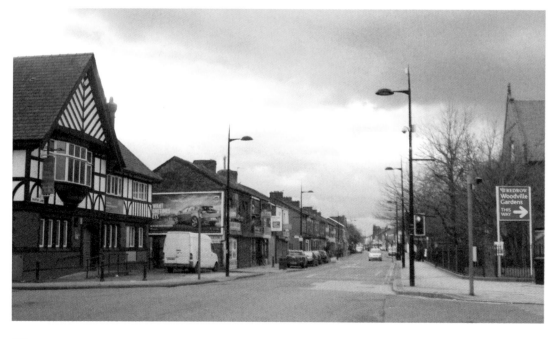

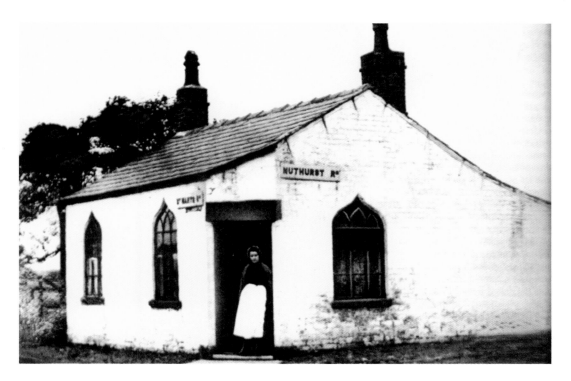

Nuthurst Road, Toll House

The toll house on the corner of St Mary's Road was demolished in 1916. It stood opposite St Mary's church, built in 1869, and was the mother church of Anglicans in Moston. The view at this corner is now of Broadhurst Park. We can thank Sir Edward Tootal Broadhurst, who in 1919 gifted the land to the Manchester Corporation. His generous gift was to the people of Moston who fought, and often died, in the First World War.

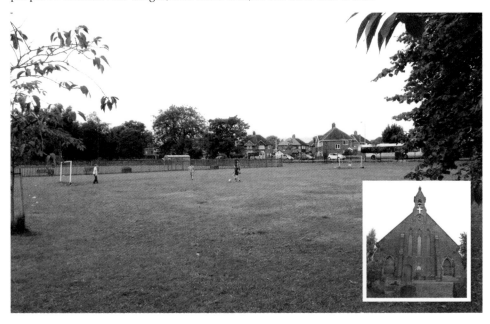

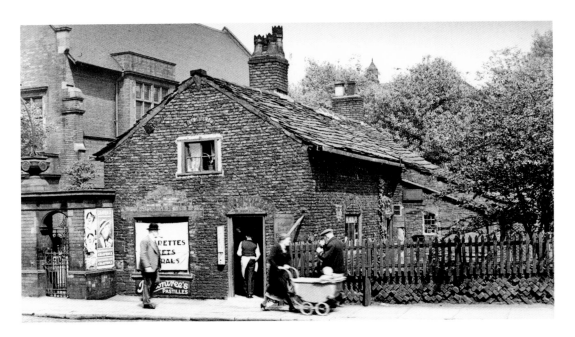

Moston Lane, Simpson Memorial, 1940

The Simpson Memorial Institute was founded in 1866 by Mrs Alice Fay, who bequeathed a sum of about £20,000 for the formation of a scheme of higher education and recreation for Moston and its neighbourhood. It opened in 1888 in memory of her father, William Simpson. This was the home of Moston Library, the first library in Manchester to adopt the open-shelf system. Again, I must claim an interest, as my first job was as a library assistant here. The institute was also home to a bowling green and a thriving bowls club.

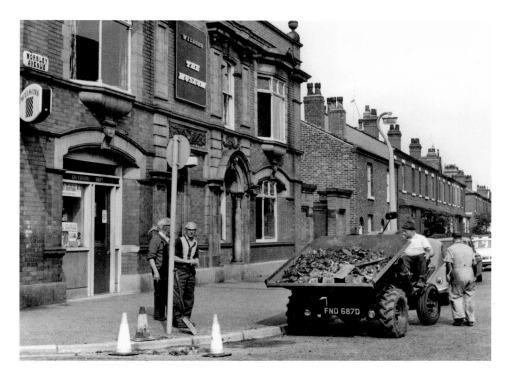

The Museum, Worsley Avenue, 1968

The Museum is named after a local taxidermist who managed the original Boggart Old Clough Inn on the site. The old cottage inn has been replaced. The Ben Brierley area is known as Street Fold. The Street family lived in the area around 1624, so perhaps that was the origin of the name. The pub is now a busy grocer's.

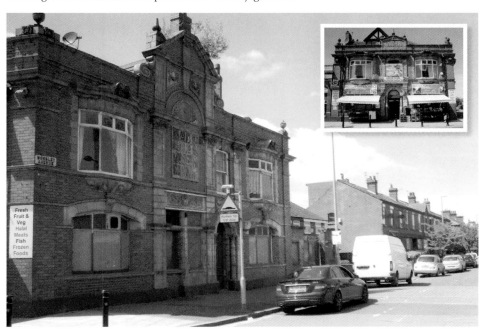

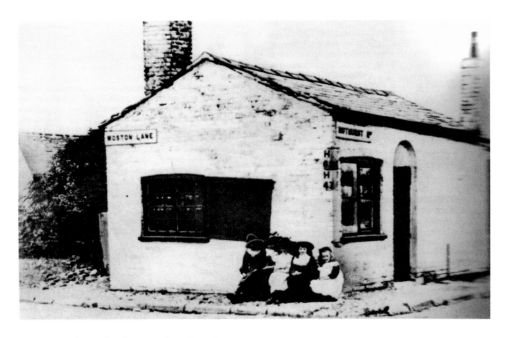

Nanny Fox's Tuck Shop at the Ginnel, 1915

This was a popular spot for the children of Moston until the end of the First World War. Opposite here on Broadhurst Fields was a transit camp for Polish families after the Second World War. In 1975, there was an attempt to build houses here, but thankfully building was not permitted as the land was donated to the people of Moston by Sir Edward Tootal Broadhurst. He stipulated that no portion of the land be used for building purposes.

White Moss, 1944

White Moss was part of the area that was disputed in the Theyle Moor dispute. The litigation lasted for most of the sixteenth century, and therefore provides historians with valuable information regarding this remote area. The people of Moston had the right to cut peat for fuel on the moor. This right was challenged by the local landowners. There were also contesting claims of ownership by the Chaddertons, the Chethams and others. This is surprising as in 1556, the area was described as 'a white moss that nothing would flourish upon'. In the 1920s, Alan Cobham's flying circus performed aerobatics on the moss. It was 5s to board a plane and enjoy a flight over Manchester.

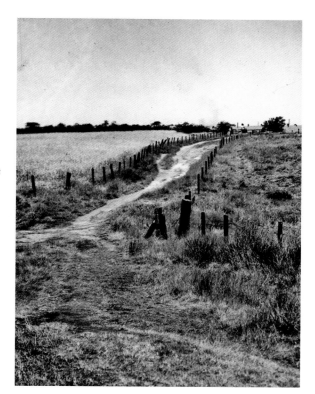

Chain Bar Toll, 1890

Chain Bar toll house was situated on Moston Lane. The toll houses were built during the eighteenth and early nineteenth centuries, with accommodation for the toll collector. Many were demolished in the 1880s when the turnpikes were closed. This one survived until 1905. James Ryder, who lived here, became the caretaker of Chain Bar Methodist church, the new church built nearby.

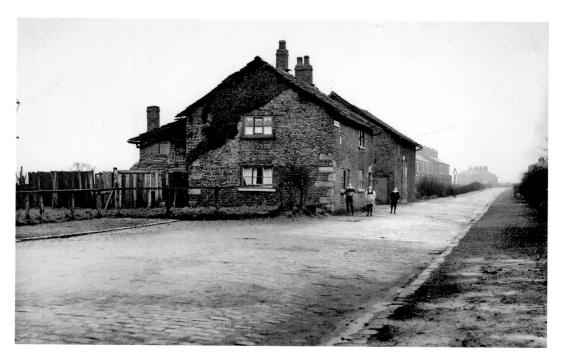

Crimbles Farm, 1907

Crimbles had an ancient history and is named on a map of White Moss in 1556. This map was drawn up for the Theyle Moor dispute. A 1927 map of Moston shows it to the right of the railway line, near to Owler Lane and Broad Lane, later named Hollinwood Avenue. I believe it was situated on what is now Moston Lane East.

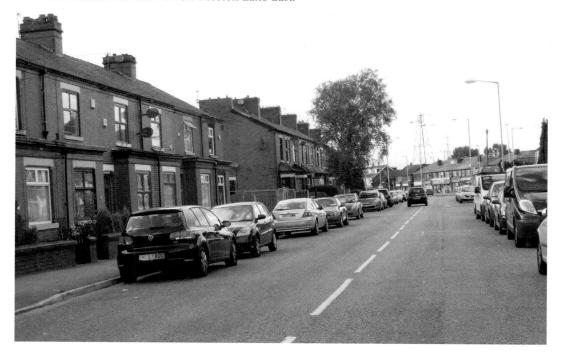

About the Authors

Jean was brought up in Blackley, and writing the captions for this book has brought back many happy memories. Jean has managed the local history collection in Halton libraries for many years. She has also created the image website for Halton (www.picturehalton.gov.uk) and has published a number of heritage walk leaflets for Halton Library Service. Recently retired, she is an adult tutor, offering courses in family history.

John has numerous, substantial production credits in theatre, television and film. He has worked for the last decade mainly in portrait, film and artscape photography. Together, John and Jean have also published *Widnes Through Time* (Amberley Publishing, 2012).

Acknowledgements

Our grateful thanks go to Dave Govier for his permission to use the photographs from Manchester's wonderful photographic collection. The image collection is comprehensive and covers a large period in the story of Manchester. I would recommend anyone who enjoyed this small collection to view http://images.manchester.gov.uk.

Thanks to George Turnbull, head of collections management at the Museum of Transport, for his advice and vast knowledge of the transport history of Manchester (http://www.gmts.co.uk). Thanks also to Northwards Housing for allowing us access for our high shots. We must acknowledge Father Brian Searle's wonderful book *The Moston Story*, which is an invaluable contribution to the history of Moston. Finally, thanks also to C. S. Jacksons for his memories of Higher Blackley in *Down Hollow Lane*, published in 1990.